Creating Nature in Watercolor

AN ARTIST'S GUIDE

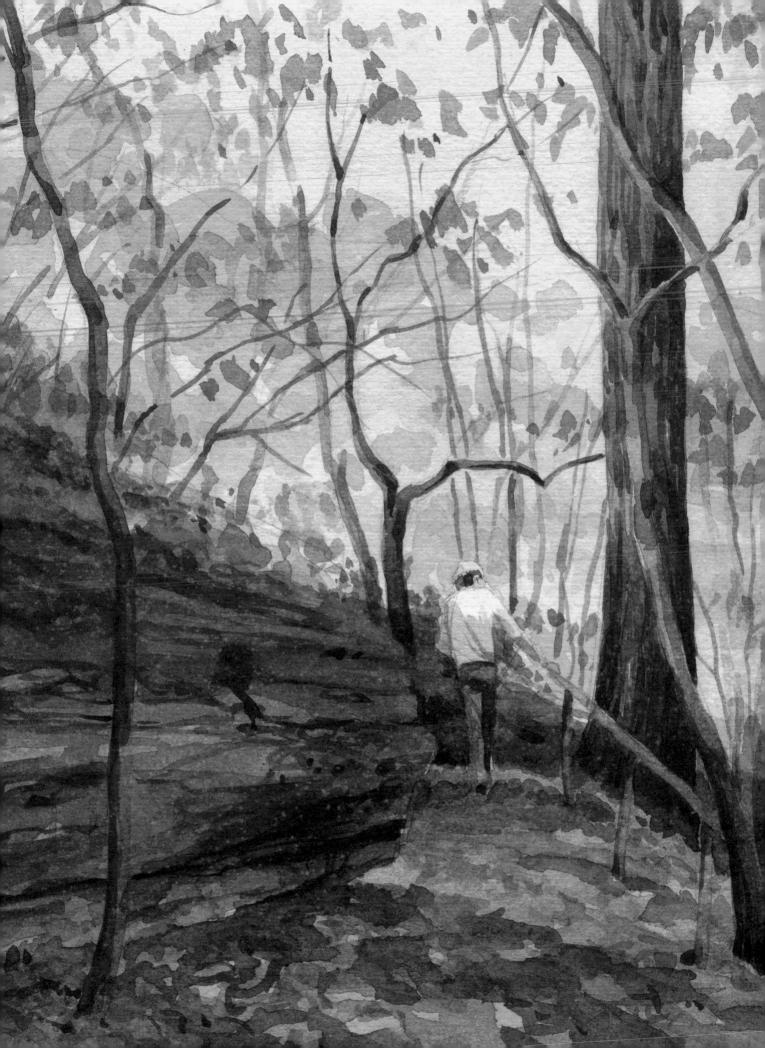

Creating Cuture
in Offatercolor

and Artist's Guide

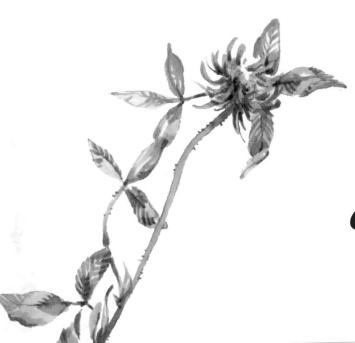

Cathy Johnson

ABOUT THE AUTHOR

Cathy Johnson has written thirty-three books, many on art. She has been a contributing editor to *The Artist's Magazine* and *Watercolor Magic* for over a decade and has written regular columns for both.

Cathy teaches drawing and watercolor online at cathyjohnson.info, where she also offers free art tips. She creates CDs for artists, also available on her webpage. Cathy writes more casually about art and life in her blog at katequicksilvr.livejournal.com. You're welcome to visit!

She lives and works in a small Midwestern town with her cats and is always open to new things.

Harris Hike (TITLE PAGE)
Watercolor on Fabriano cold-pressed paper
12" × 10" (30cm × 25cm)

Creating Nature in Watercolor: An Artist's Guide. Copyright © 2007 **by Cathy Johnson.** Manufactured in China. All rights reserved. No part of this book may be reproduced in any form or by any electronic or mechanical means including information storage and retrieval systems without permission in writing from the publisher, except by a reviewer who may quote brief pas-

sages in a review. Published by North Light Books, an imprint of F+W Publications, Inc., 4700 East Galbraith Road, Cincinnati, Ohio, 45236. (800) 289-0963. First Edition.

Other fine North Light Books are available from your local bookstore, art supply store or direct from the publisher at www.fwbookstore.com.

12 11 10 09 08 5 4 3 2 1

DISTRIBUTED IN CANADA BY FRASER DIRECT 100 Armstrong Avenue Georgetown, ON, Canada L7G 5S4 Tel: (905) 877-4411

DISTRIBUTED IN THE U.K. AND EUROPE BY DAVID & CHARLES Brunel House, Newton Abbot, Devon, TQ12 4PU, England Tel: (+44) 1626 323200, Fax: (+44) 1626 323319 Email: postmaster@davidandcharles.co.uk

DISTRIBUTED IN AUSTRALIA BY CAPRICORN LINK P.O. Box 704, S. Windsor NSW, 2756 Australia Tel: (02) 4577-3555

Library of Congress Cataloging in Publication Data
Johnson, Cathy (Cathy A.)
Creating nature in watercolor: an artist's guide / Cathy Johnson.
p. cm.
Includes index.

ISBN-13: 978-1-58180-913-8 (hardcover: alk. paper)
ISBN-13: 978-1-60061-148-3 (hardcover: alk. paper) (UK only)

1. Watercolor painting--Technique. 2. Nature (Aesthetics) I. Title.
ND2237.J59 2007
751.42'243--dc22 2007021552

Edited by Mary Burzlaff
Cover Designed by Wendy Dunning
Interior Designed by Jennifer Hoffman
Production coordinated by Matt Wagner

METRIC CONVERSION CHART

to convert	to	multiply by
inches	centimeters	2.54
centimeters	inches	0.4
feet	centimeters	30.5
centimeters	feet	0.03
yards	meters	0.9
meters	yards	1.1

DEDICATION

To Himself, with love.

ACKNOWLEDGMENTS

Like every author before me, I owe a great deal to the people who assisted me in the months and years leading to the creation of this book. To my editor Vanessa Lyman, who shepherded the project from the initial concept to its conclusion (and through my many computer glitches!), I owe my deepest thanks. To production editor Mary Burzlaff, to designer Jennifer Hoffman and production coordinator Matt Wagner, I owe my appreciation for their hard work in making this book a tangible reality.

Thanks also to Jim Cohee and Sierra Club Books, as well as to *Country Living* magazine, where I was staff naturalist for eleven years, for allowing me to reuse a few pieces of art that appeared in their pages.

My artist friends, Keith and Jeri Bowen, Keith and Roberta Hammer, Laura Frankstone, Karen Winters and Jana Bouc were always encouraging and supportive, as were Susan and Andy Theroff, Jytte Klarlund, Kevin and Sonya Morgan, and Ginger and Jim Nelson. My dear niece Jenny showed me her desert; my sister and brother-in-law, Richard and Yvonne Busey, encouraged and supported me and put me up while working on the spot, as did my future in-laws, Chet and Clare Ruckman. I love them all dearly for it.

My friends and family helped keep me centered and sane. My wonderful students inspired me, asked insightful questions and offered suggestions that helped make this book more complete and, I hope, more useful.

And last but never, ever least, my deepest thanks to my knight, Joseph, who held my hand; met my planes; kept me fed; carried my art supplies; showed me the ocean; drove me through the desert, up and down mountains and across many states; and painted by my side—he is always there when I need him.

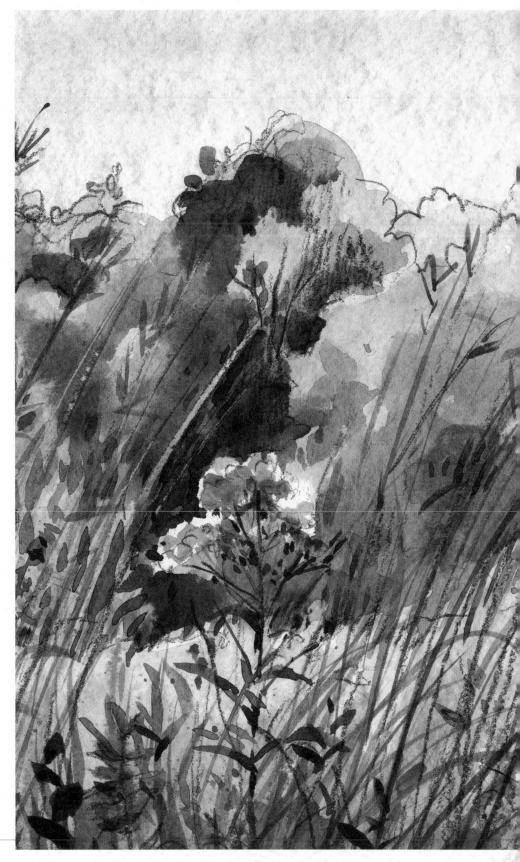

Ironweed Watercolor and colored pencil on Canson Montval cold-pressed paper 12" × 9" (30cm × 23cm)

Table of Contents

- 7 INTRODUCTION
- Keeping an Artist's Sketch Journal 8 Choosing a Journal · How to Get Started · Creating a Field Journal · Learning From

Your Own Art • Asking the Right Questions • Bird Watching With Journal in Hand •

Travel Journal • Doing What You Have to Do • Demonstration: Field Journal

Materials and Supplies 22

What to Buy, What to Try · Working on the Spot—Tools for Travel · Prepping for Mixed Media

Getting Started: The BasicsWashes · Composition and Format · Color Choices · Values 30

Into the Woods—Forest Habitat 38

> Tree Shapes • Tracking the Seasons • Demonstration: Trees From a Distance • Leaves and Tree Bark • Denizens of the Forest—Plants and Creatures • Birds • Demonstration: Weston Bend

By the Water 50

Indigo Magic • Still Water—Lakes, Ponds, Coves, Marshes • Demonstration: Maine Coast Morning • Reflections and Wave Patterns • Fast-Moving Water—Rivers and Streams • Ocean Habitat—Tidal Zones and the Seashore • Demonstration: Cliff House • Natural History Sketches—Plants and Wildlife • Painting a Waterfall · Demonstration: Promised Land

Prairies, Meadows and Fields 68

Format and Focus • Trees That Follow the Watershed • Wildflowers • Cultivated Fields • Birds of the Grasslands • Limestone Fence Posts and Windmills • Mammals of the Grasslands • Demonstration: Bison

Mountains 82

> Mapping Mountains • Trees of the Eastern and Western Mountains • Mountain Wildflowers • Mountain Wildlife • Demonstration: Mountain Sheep • Birds of the Mountains • Demonstration: Mountain Painting

96 Deserts

Desert Colors • Demonstration: Ground Squirrel • Desert Wildlife • Demonstration: Trying Out Desert-Toned Paper • Signs of Early Occupation • Desert Plants • Demonstration: Raven's Hole

Humans in Landscape 110

 $Including \ Humans \ \bullet \ Going \ Camping \ \bullet \ Canoes, Kayaks, Dories \ and \ Jon \ Boats \ \bullet \ Demonstration: Sunset$ Canoes • Fishing • Hiking or Walking in All Weather • Small-Scale People • Demonstration: Landscape With Figure • Implied Humans • Demonstration: Variations on a Theme

- 126 CONCLUSION
- 127 INDEX

Introduction

For an artist, working on the spot—in nature, en plein air, whatever you want to call it—can be a delight, a wonderful challenge, the ultimate high. And, yes, it is a challenge—nature sees to that! The changing light alone tests our skill and speed and our powers of observation.

Still, there are so many reasons to work outdoors: to drink in the beauty of nature; to find fresh, evocative, inspiring and challenging subjects; to spend time in the quiet places; to capture the liveliness of birds or the grace of a red fox; to learn about your environment; to perfect your skill; and just to be out where it's achingly beautiful. Whether you take a painting vacation, a field trip led by a naturalist/artist, a trip to some exotic, untouched locale or find painting subjects virtually in your own backyard, you will find subjects enough for a lifetime.

Of course, it isn't necessary to complete a whole painting outdoors. You may prefer to sketch a variety of subjects with pencil, ink, colored or watercolor pencils, even mixed media with quick watercolor washes, then return to the comforts of home to do a more finished piece. You can take photos, both from a distance and close up. I'll show you how to put these resources to work!

We'll discuss the various mediums and try out the techniques together, and I'll offer some of my favorite quick tips and hints for capturing textures. We'll cover some of the basics, but also explore more specific and advanced techniques.

This book is organized by habitat. Each chapter includes the variety of things you will find in that specific habitat and hints on how best to capture these elements in your sketches and watercolors. The forest habitat chapter, for instance, will show you how to capture individual tree shapes, bark patterns and leaves as well as forests from a distance and in their varied seasons. You'll also learn to paint the wildflowers that bloom in the spring and the birds, insects and animals that frequent these places.

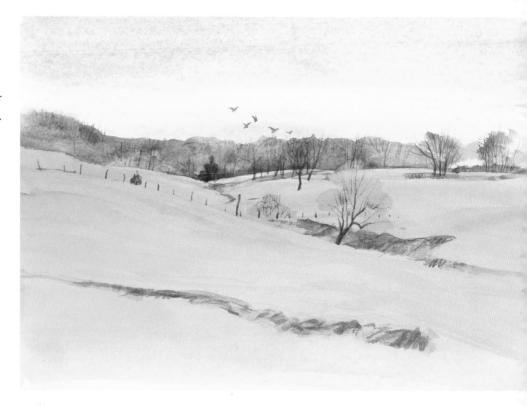

Winterscape Watercolor on Fabriano hot-pressed paper 9" \times 12" (23cm \times 30cm)

There is a bit of the naturalist in most of us. Painting and drawing this marvelous place we inhabit allows us to slow down and learn with our own eyes, to notice, to pay attention. The child within is still curious about that big moth or the tiny, brightly colored mushroom that grows along a fallen log. How better to explore than to observe and draw or paint?

Perhaps Baba Ram Dass was not thinking of artists when he said, "Be here, now," but that injunction certainly applies to painting in nature. We look, we see, we pay attention, we learn . . . and we delight in it!

Whether you love an aromatic, crackling campfire, a mountain stream, the robust wild-flowers of summer or the calligraphy of tracks in the snow; whether you find time for canoeing, fishing in the early morning, watching the birds that frequent your locale or stealing silently almost within touching distance of a deer and her fawn, you will find magic in this

natural world. As an artist, getting it down in concrete form is to capture those moments forever, golden as a fly in amber. Your paintings and sketches will have the power to return you to that moment in time. No matter how busy and frenetic your everyday life, these tangible evidences of time in nature will transport you back to those magical moments.

CHAPTER ONE

Reeping an Artist's Sketch Journal

ournaling is a subject close to my heart; I've kept journals of various types literally for decades. I keep my sketches, thumbnails, studies and other plans for future paintings here. I also make gesture sketches, contour drawings, even stick figures. I test new materials or plan out different color possibilities for paintings. I draw my friends and neighbors, my cat and dog friends, and I entertain myself when I have to wait by filling up the pages of my sketchbook. I even sketch when I'm nervous. It helps me focus on something outside of myself.

When I record artifacts in museums, I use my journals to study natural history and human history. I keep a visual record of a special trip to a beautiful place, whether it be San Francisco's Ocean Beach or a quiet lake in the Adirondacks. Travel journals allow us to revisit these places every time we open the pages of a book, reminding us not only of what we saw but of the sounds and smells and even our own thoughts and emotions.

I also keep my grocery lists, to-do lists, telephone numbers and notes of meetings in the same journal. It has become an integral part of my life.

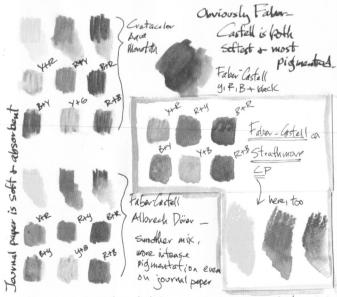

It makes a great deal of difference which color you put down 1st.

Choosing Your Journal

I recommend a hardcover journal rather than a regular sketchbook. You're going to be giving it hard use, and it needs to stand up to travel and weather!

There are any number of journals to choose from, in a variety of sizes and shapes—from handmade journals (I like making my own, so I have the exact paper I prefer to work on) to commercially available products. Try to find one with paper heavy enough to withstand at least light watercolor washes—you'll likely want to add some color. (Watercolor pencils work well and are less likely to buckle the paper since they take less water.)

Record Experiments

Your sketch journal is a great place for trying out new materials so that you have a permanent record in a place you can find easily. Here, I compared watercolor pencil brands on various papers, then glued them into my journal for easy, permanent access. In the lower right is the page number—it's even indexed to make it easy to find!

How to Get Started

First, decide what kind of journal and format you want—a traditional rectangular landscape or portrait format, a square or an elongated rectangle for wide vistas. (I find the latter slightly harder to work on—the extra length seems to get in my way.) Choose the kind of paper you want for drawing in graphite, ink, colored pencil or painting. Strathmore's spiral-bound watercolor journal offers a choice—their excellent watercolor paper is interspersed with lightweight drawing paper, which lets you sketch, paint and take notes, all in one place.

Canson and American Journey also offer nice, hardcover water-color journals, as do several other companies. Look around, experiment and find the perfect choice for you. And, of course, you can always make your own. Bind them with the aid of a good instructional book like Dover's *Hand Bookbinding: A Manual of Instruction* by Aldren A. Watson. That way, you'll have the paper you prefer working on in the size you want.

If that seems too time consuming, consider cutting your favorite paper (I prefer Fabriano Artistico, myself) to size, and take the stack to a copy shop. They'll spiral bind it with a sturdy cover quickly and at a reasonable cost, and you can even alternate watercolor paper, drawing paper and toned paper, if you like.

You'll also want a good watercolor field kit. A lightweight container for water or a selection of watercolor brushes; a mechanical pencil; a gray, black or indigo wax-based colored pencil and a set of watercolor pencils should be sufficient for keeping an artist's journal.

What you start with depends on how wide a focus you plan for your journal. Will it encompass your whole life? Will it be a "themed" journal, with a monthly or yearly theme? Will it be a nature journal or a travel journal? I prefer mine to contain everything under one cover—whatever's going on in my life. However, I began first with a sketchbook dedicated just to art, and then moved to a nature journal. Another pad held notes and lists. Now all this is under one cover, and life is much more integrated!

A compact bag to carry all this in can go with you everywhere. Mine started out life simply as a dedicated field kit—I'd carry it in addition to my purse and whatever else I needed, whenever I went out of the house. I finally simplified things considerably and just put a credit card, driver's license and checkbook into my field kit. Now it is my purse. You'll find more detailed information on all of these important considerations in the materials section of chapter two (see pages 22–27).

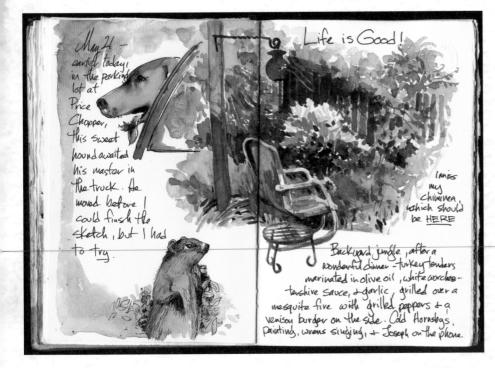

Capture Your Day

Work across a two-page spread if you like, and create a montage of a single day. Just keep adding till you run out of room. Design the page, use a grid with small, quick sketches or allow your design to evolve naturally to fill as much space as it seems to need.

Here, the morning's grocery shopping included a sketch of a sweet hound waiting for his master, an ink sketch of the woodchuck that frequents a den under my deck and a watercolor of my backyard jungle completed later in the day. I added color to the dog and woodchuck later.

This is in my hand-bound journal with hotpressed watercolor paper.

Creating a Field Journal

If you want to keep a naturalist's field journal, consider the things that will clarify and help you identify what you see later. In addition to my normal art supplies, I might take a 6-inch (15cm) ruler and a magnifying glass. I even have a hand microscope that goes with me on occasion.

A journal can be a true "tool for learning," as artist and naturalist Clare Walker Leslie calls it. As you draw and paint in nature, you will take time to get to know an area as you seldom would when just passing through. You respond, you question, you record the things you see and . . . you slow down. It's as much your own experience, your own life you're recording, as the life around you.

WHAT TO INCLUDE IN FIELD JOURNAL NOTES

On the art itself, you'll want to include field notes and other observations. Include the date, the time, the weather and the type of habitat in which you find your subject—prairie, forest, wetlands or backyard. If your subject is animate, write down what it's doing—feeding, nesting, claiming territory? If it's feeding, on what? (That may help you identify the bird you're looking at later, if you don't recognize it—some prefer thistle seeds, some worms or bugs.)

Draw or paint your main subject, but also as many details as you have time for. If it's a flower, for instance, zero in on the leaf, stem, bud or seed—whatever you can find. Add color, if you can, either in reality or as written notes. All of these will help you to identify it later.

Write down what other plants grow nearby, or what mammals, reptiles, insects or birds you can see. Include a small habitat sketch in one corner, if you like.

You can even note the sounds you hear. Birdsong, insects in the grass, human voices—all those notes will help bring back the moment clearly to you later.

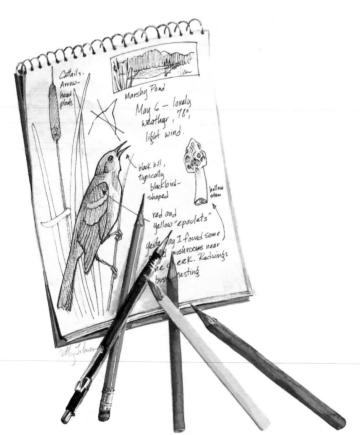

Sample Field Sketchbook Page

This detail of a larger illustration was done for Country Living magazine when I was their staff naturalist. It shows a field sketchbook page with many of the things I like to include.

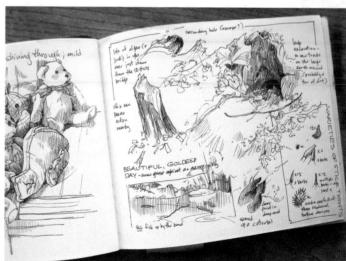

Nothing Is Too Small

Typical of my field journal entries, this page includes enough notes and sketches to allow me to remember even the most minute details. Nothing's too small to notice, even the variety of seeds you pull out of your socks! As you can see from the stuffed animals on the facing page, my journal really does include all aspects of my life.

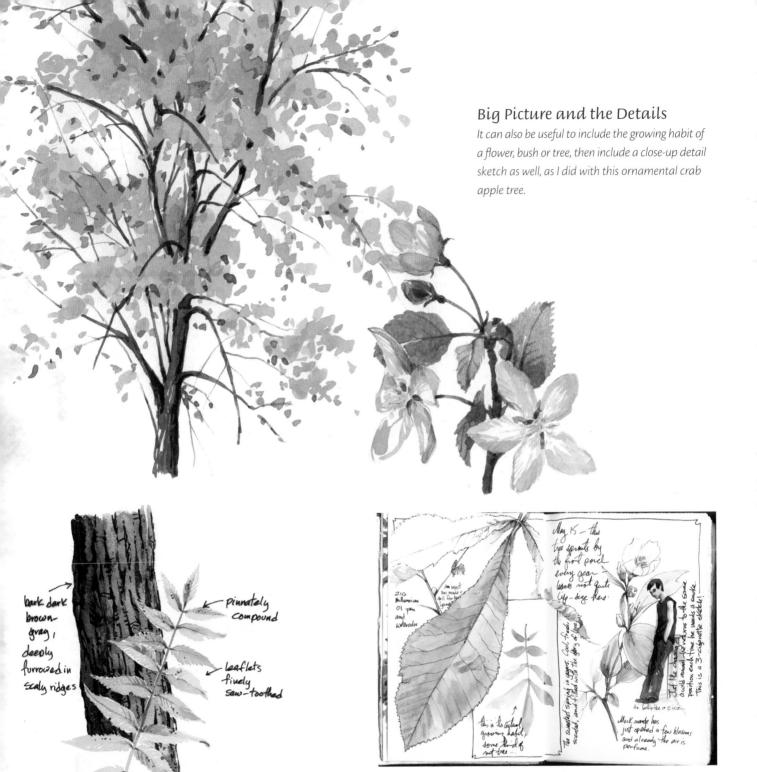

Include Color

leaflets

Watercolor is terrific for this kind of nature study, letting you capture color as well as shape and growing habit. Here, the green husk of the walnut contrasts with the golden leaves of autumn. The detailed study of the bark would allow me to identify this tree later if I didn't already know what it was.

A Specific Moment

Include everything you find at a specific moment in time—here, a close-up of a leaf by my porch, a silhouette of its growth pattern, an insect gall on its stem, a flower from the mock orange that grows nearby and my neighbor, out for a smoke on his front porch. I even noted the art supplies I was using. Hoved the feel of the pen and wanted to remember which one it was.

Learning From Your Own Art

12

There are times when you see things in your rambles that make you stop and ask, "What on earth is that about?!" If you take the time to sketch or paint what you see, sometimes you can find an answer to that question. Once, out by my creek, I discovered a woodchuck up a tree and quickly sketched him. No one would believe what I had seen until I showed them my sketch. Eventually, I asked the right person with the Missouri Department of Conservation, who told me that climbing woodchucks are not all that uncommon!

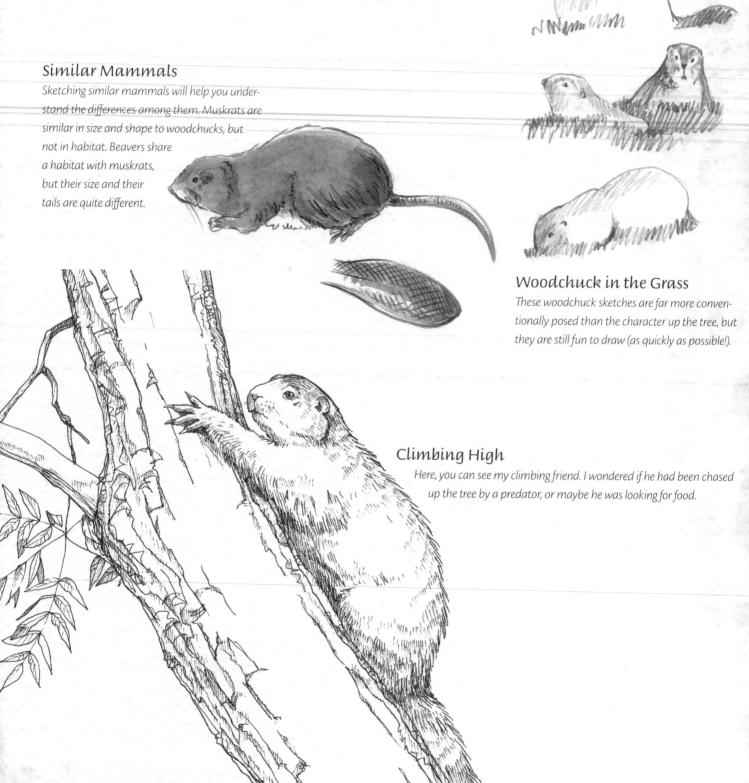

Asking the Right Questions

Write down as much as you can observe about what you see, even if it appears to make no sense to you. Sketch as many details as you can, and note your questions: what puzzles you, what don't you understand, what's new to you, what seems out of place or different? With any luck, you can find the answers in a field guide or by asking an expert in the field.

Bank Swallows

Years ago, I saw a pair of very active little birds up the creek near my home. I watched them for a long time, delighting in their swooping flight and their balancing act. I wasn't sure what these fast, stubby little birds were. I drew them as they sat and preened, and later identified them as bank swallows from my rough sketches and from my memory of their actions.

Fascinating Finds

It was fascinating to find these "nested" leaf cases tucked into a hollow branch. Most likely, a wasp had parasitized the eggs of an ant.

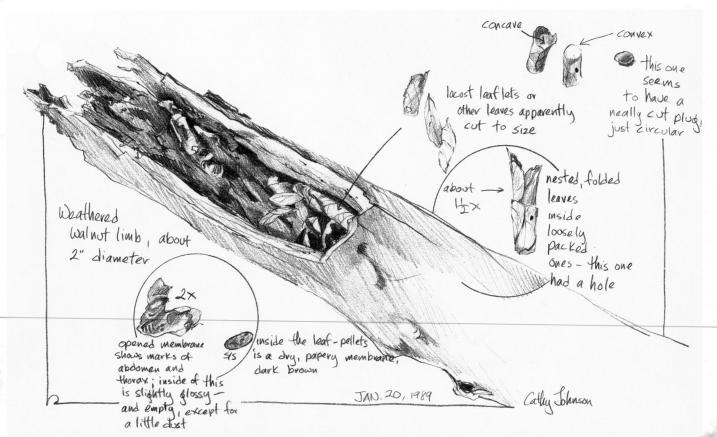

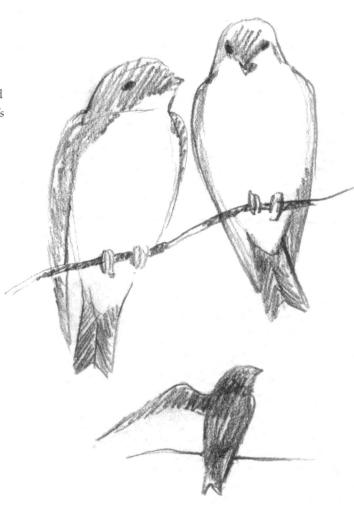

Bird Watching With Journal in Hand

Many people keep a "life list" of birds, but your journal is a perfect place to record sightings, oddities, questions and more. Get the feel for a specific location through the birds that nest there (or pass through on their migration paths).

— Quick gesture sketches or longer studies, incidental sketches or drawings that take the whole page (even supplemented with photos or field guides if necessary) can make your journal an invaluable birding resource.

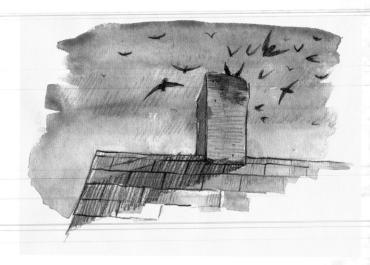

January 4 - they appear to be entired bervies from the sure of with brown poop what is noting the Jeep with brown poop that you with brown poop that you shall be the forther such success to the solvist thought when success too...

a lot of sil houstles idainst the sky. This afternoon I got a better one of an individual off the front pouchs but success too...

Winter Robins

Use your journal to record unusual happenings. Although we always have a few robins winter here in the Midwest, especially out in the woods, one year they stayed in record numbers, even in town. I tried photographing the flocks that frequented my backyard, wondering what they found to eat. (Robins are not seed eaters, so putting out feeders isn't helpful.) My photos were too distant and fuzzy, but my quick sketches really caught something of the phenomenon.

Bird Behavior

You can record bird behavior in your journal, too. Take time to watch behavior, even if you have to do it several days in a row. I watched the chimney swifts' nightly ritual over a period of three evenings until I really got a feel for their routine. They'd dive toward their chosen roost in my neighbor's chimney, then drop down into it, one at a time, in a great black funnel of birds.

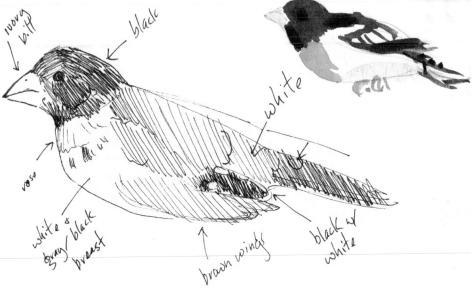

Memory Sketches

When doing bird studies in your journal, memory sketches are a big help. Often, a bird stays no longer than a minute in a single place, but, if you've practiced sketching from memory, you'll be surprised at how much you can recall. The annotated ink sketch of the rose-breasted grosbeak in my journal wasn't that far off from the markings I added later, in watercolor.

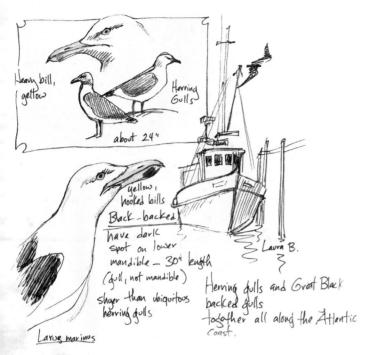

Reference Notes

If you're as specific and complete as you can be with your notes, you can use your annotated field sketches for reference. Here, I sketched great blackbacked and herring gulls at the wharf in Port Clyde, Maine, in 1991. I was able to get close enough to observe and note details, then fleshed them out from a field guide back at the hotel. I also added the color later.

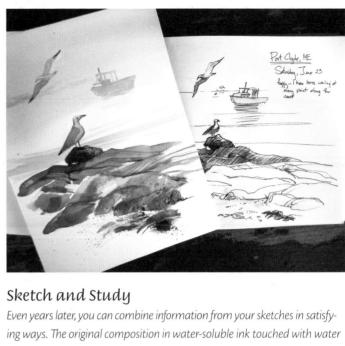

Even years later, you can combine information from your sketches in satisfying ways. The original composition in water-soluble ink touched with water for halftones came from another journal entry a few pages before the gull sketches, at left. I was able to use information from the close-up sketches to make the whole more believable.

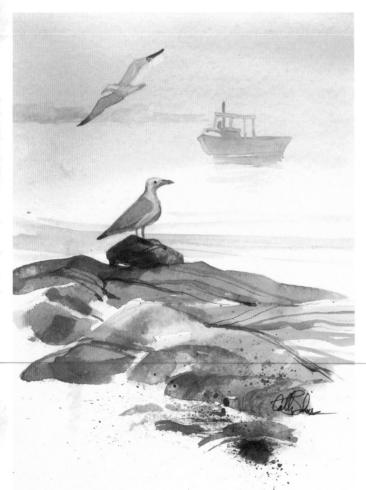

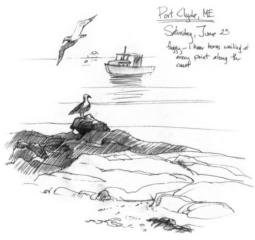

Original Sketch

This is a close-up of the original sketch done in 1991.

Final Study

This little watercolor study was done fifteen years after the original sketch!

Morning Gulls
Watercolor on Stonehenge cold-pressed paper 7" x 5" (18cm x 13cm)

Travel Journal

One of my favorite uses for my hardcover journal is keeping a record of my travels. I nearly filled a journal the year I went to Maine, and I have worked from my sketches many times since. Let yourself go—paste in bits of memorabilia if you like, along with your sketches. Ticket stubs, boarding passes, business cards, a menu—all these can add special flavor to a travel journal.

Maine Landscape

This watercolor pencil painting was done from an ink sketch I made on a trip to Maine to teach a workshop. I'd get up every morning before the sun and walk for miles, delighting in the landscape and sketching what I found on my rambles.

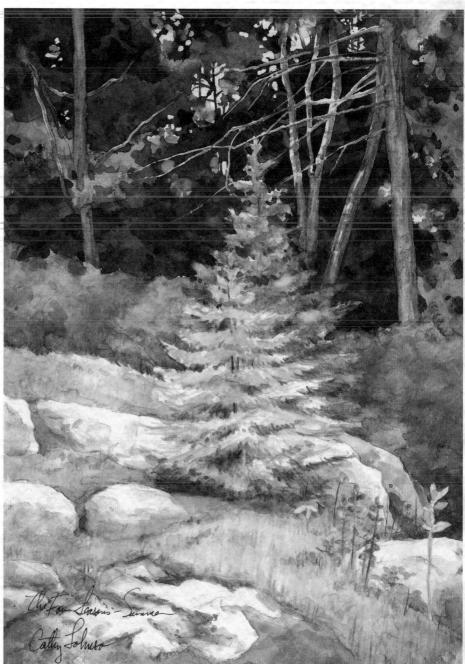

Someone to Watch Over Me Watercolor pencil on Strathmore cold-pressed paper $10'' \times 7''$ (25cm \times 18cm)

Finished Painting With Original Sketch

Here's the same painting with the original travel journal sketch.

Wildflowers

I was delighted to find a variety of wildflowers near our camp on Lake Durant. I had intended to paint them all, but we ended up exploring the area, and then a rainstorm blew up, so this was all that got finished on the spread.

There are two different colors of background because I used both Fabriano hot-pressed and Aquarius paper in my hand-bound journal. They don't look very different until you scan them.

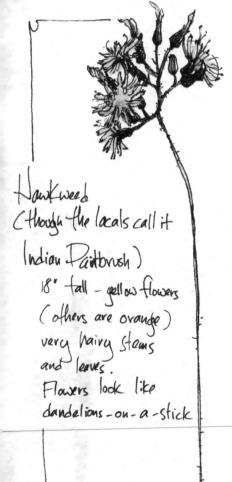

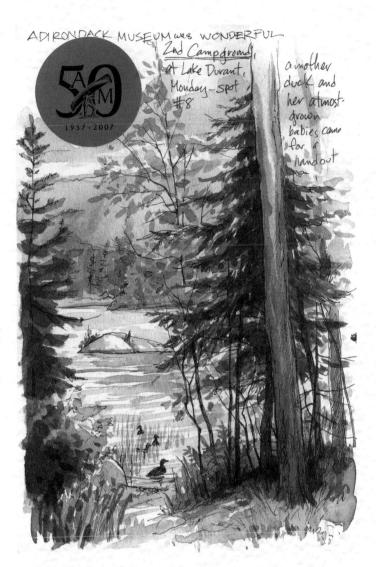

Lake Durant, New York

This was our second camping trip in the Adirondacks, all by ourselves. It was lovely, except for the black flies! The ducks would come up to the camp, expecting a handout, with their ducklings in their wake. We had visited the Adirondacks Museum, and I didn't want to lose the sticker, so I just put it right on the page with my drawing of the view over the lake from our camp.

Quick Ink Sketch

When we travel, we often have deadlines, schedules or other people pulling us this way and that. If you don't have much time, just do a quick ink sketch with color notes. You can always add the color later, as I did here.

Port Clyde, Maine

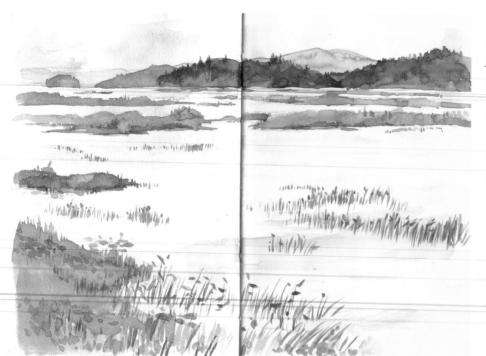

Go Wider

Again, don't feel constrained by a single-page format. If you want a larger space, work across the page. Some earlier traveling artists actually pasted in yet another sheet when they wanted a broad landscape, so they had three page widths.

This watercolor done at New York's Tupper and Raquette Lakes needed space, so I used two pages. Again, two different types of paper in my hand-bound journal made the difference in scanned colors.

. . . Or Work Longer

Sometimes we have only a short while, and other times we can work for a much longer period. Construction workers were working on the road in Nevada's Valley of Fire, and we had to wait for a pilot car to lead us through the construction zone. I didn't realize when I began that I'd have time to do a pretty complete landscape sketch.

Study Details

If you've got a longer period of time, make a study of some of the details you find in your travels. These studies are a variety of desert plants outside Henderson, Nevada, in watercolor.

Doing What You Have to Do

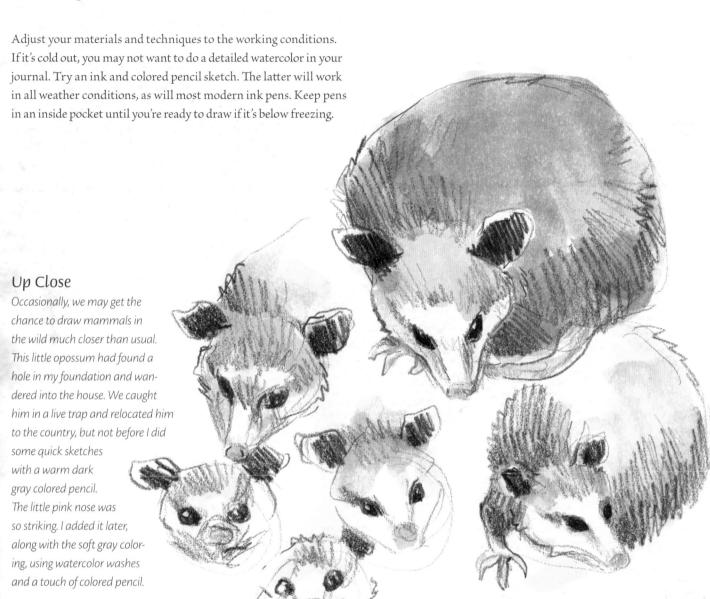

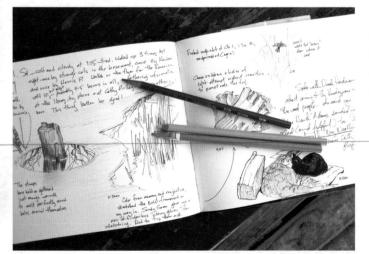

Winter Sketching

It was bitter cold when I did this sketch at my pond. The dark stump had absorbed enough of the sun's warmth to melt the ice around it, resulting in a reflective circle of water. I did the sketch on the spot with my ink pen and a very limited selection of colored pencils.

Field Journal

Your journal sketches and paintings can be as simple or as complex as you wish. If you're relaxed and comfortable with no particular place to be, you can do a complete painting or a detailed field study, even in a smaller journal. Nature studies, details, a landscape in preparation for a larger painting, travel notes or whatever, your journal is the perfect place to keep these memories in one place.

MATERIALS

SURFACE

Fabriano hot-pressed paper

PIGMENTS

Burnt Sienna, Cobalt Blue, Permanent Alizarin Crimson, Phthalo Blue, Transparent Yellow

BRUSHES

9mm, 12mm and 15mm round and 12mm flat Niji waterbrushes

OTHER MATERIALS

fine-tipped marker

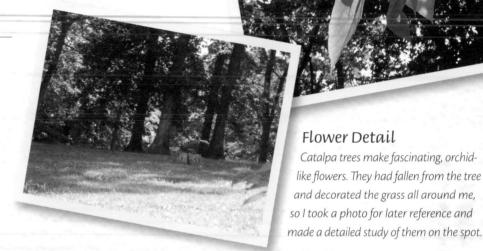

Choose a Location

I found a comfortable place to paint in the shade of a catalpa tree. I loved the sunny landscape across the park.

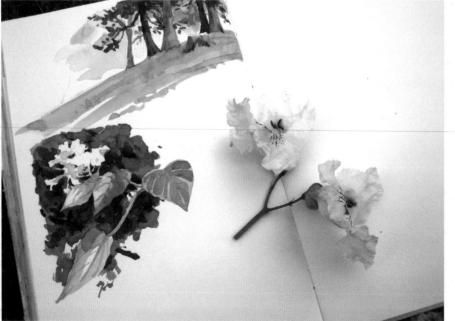

Sketch the Flowers

Flower Detail

Catalpa trees make fascinating, orchid-

like flowers. They had fallen from the tree

I did a simple landscape at the top of my page, then sketched in the flowers as they looked at a bit of a distance, at middle left. I was interested in their growing habit on the stem and the shape of the leaves. I began painting them as carefully as I could, using my Niji waterbrushes.

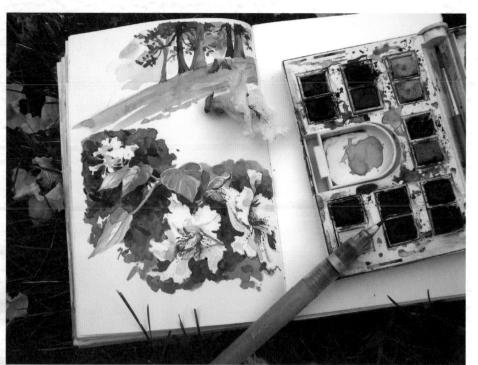

Add the Details

Next, I added the close-ups of the flowers, working as accurately as I could from the real thing. When painting flowers on the spot, pay attention to details. Are the petals separate or are they attached like ruffles at the edge of a cone, as they are here? How many are there and how are they arranged?

Here I used Phthalo Blue and a pale wash of Cobalt Blue to model the flowers and added Transparent Yellow and a mix of Burnt Sienna and Permanent Alizarin Crimson for the details.

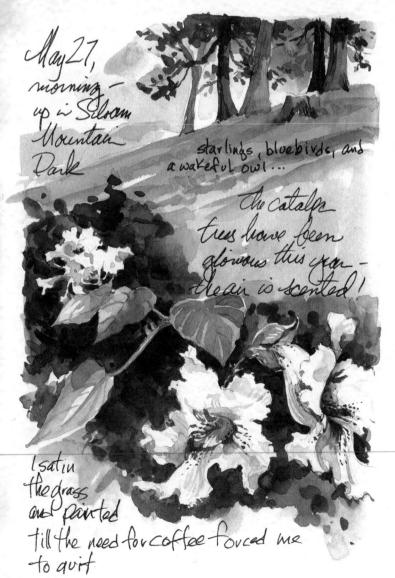

Make Notes

Finally, I added the unifying Phthalo Blue background wash and allowed the watercolors to dry. Then I added the notes in ink, using a fine-tipped marker. I wrote down the date, the sounds I heard, birds I saw nearby and other pertinent information, including my need for coffee! Every time I look at that page in my hand-bound journal, it really brings back that lovely May morning.

Catalpa Tree Watercolor on Fabriano hot-pressed paper 7" × 5" (18cm × 13cm)

CHAPTER TWO

Materials and Supplies

hat to buy, what to try: The supplies you end up using depend a lot on whether you want to work en plein air or in the comfort of your studio. We'll touch on both options. It also depends on how much you want to spend, and whether you like to work as simply as possible or have all the bells and whistles at your disposal. I tend toward the simpler model these days, but I have indeed tried out many other options on my way, so we'll discuss the possibilities there, too.

Just remember—there's no "right" way. What is important is finding the tools that allow you to work the way you want to and capture what you want! That means that some exploration is in order.

Brushes

Your basic brushes should include a round and a flat, as shown, though you will probably prefer a wider range of sizes. For me, basics include nos. 3, 5 and 8 or 10 round as well as ½-inch (13mm), ¾-inch (19mm), 1-inch (25mm) and sometimes even 1½-inch (38mm) flat.

In addition to these basics, I often use a barbered fan brush, a stencil brush for spattering and a few small bristle brushes, sometimes with the ends broken off and sharpened.

Many flat brushes come with what is called an "aquarelle" tip, like the green one at right. This gives you an additional painting tool—you can incise dark lines into your washes or push damp paint out of the way for lighter lines.

Pencils

Most of us like to sketch at least a bit before jumping right in with watercolor. Sketching feels familiar and comfortable and gives us a little guideline. A good old no. 2 pencil will be fine for this purpose, or an HB drawing pencil (there are harder and softer pencils if you prefer, but HB is very versatile). Consider a mechanical pencil, especially for field work, since it doesn't require a sharpener. If you like, try a black or dark gray colored pencil as an alternate drawing tool. They're not as erasable as graphite, of course, but they do make a bold line that won't lift or smear if you paint over it.

You can use a regular pencil sharpener, either manual or electric. Or, try sharpening your pencil with a knife blade to achieve a more versatile and often stronger point (see yellow pencil on the left).

Surfaces

For working at home, you may want to buy full sheets of watercolor paper (usually 22" × 30" [56cm × 76cm]) and cut them to the size you want. If you get 300-lb. (640gsm) paper, it won't need to be stretched or taped to a support, but 140-lb. (300gsm) paper is sufficient for most needs. Tape it to a support with masking or drafting tape and you won't have much buckling. Any small hills and valleys that form will generally flatten back out as the paper dries.

You can also buy pads or watercolor blocks. The latter are comprised of multiple sheets, glued together on all four sides, with a small opening to allow you to insert a blunt blade to free a dry, finished painting. If the paper is 140-lb. (300gsm) or better, there is virtually no buckling with blocks, no matter how wet you paint. Watercolor blocks are great for travel or field work.

There are three common surface textures in watercolor paper: rough, hot press and cold press. Cold press may be the most versatile, but many watercolorists like rough paper for a variety of textural effects. It is more difficult to control your washes on hot-pressed paper, but it can be very exciting, splashy and puddly. Try them all to see which you prefer.

As always, buy a good brand—I like Fabriano, Arches or Strathmore. Inexpensive papers may have a nasty mechanical texture or refuse to take washes well. Some are too absorbent or buckle excessively when wet. Nothing is as discouraging as trying to paint on inferior or student-grade stuff.

NOTE

For use with watercolor pencils or watercolor techniques involving lifting or scraping, you will be happiest with a tough, hard-surfaced paper. Softer, more delicate papers are best reserved for traditional painting techniques.

Watercolors—Tube or Cake?

There are many choices for watercolorists. The products you choose will depend on your own comfort level and convenience. Artist-quality paints are nearly always a better choice than student-grade. They mix better and are more concentrated and pigment-dense. In the long run, good paints are economical: They'll go much farther because you can use less pigment. Colors are more intense and the texture is smoother. They also tend to be more lightfast, though the better grades also offer specific pigments

that are not. Most of the pigments that I mention in this book are from Winsor & Newton, though I also experiment with some of the Daniel Smith and M. Graham & Co. colors. Try a variety of brands.

If you buy a set, you may get tube or moist pan colors—
the latter will still re-wet well. The only drawback to buying a set
is that they often come with tiny halfpans, which are more
useful for sketching than painting anything larger than 7"
× 10" (18cm × 25cm). Also, be aware that someone else—

has decided what colors you will want, and they're not always right. You can buy open-stock replacement pans in colors that you like in most brands, or you can get empty full or half pans and fill them yourself with tube pigments.

Palette-able Advice

Another option is to get an empty palette and fill it with tube paints yourself. There are many styles, sizes and types of palettes. Allow the pigments to dry at least 24 to 48 hours before taking the palette into the field, or you'll wind up with an oozy mess! You can buy a small, versatile, folding palette like the one in the illustration at right (great for field work!), or a full-size one for studio or serious plein air painting—I've used the same old John Pike palette for thirty years, and it's still going strong.

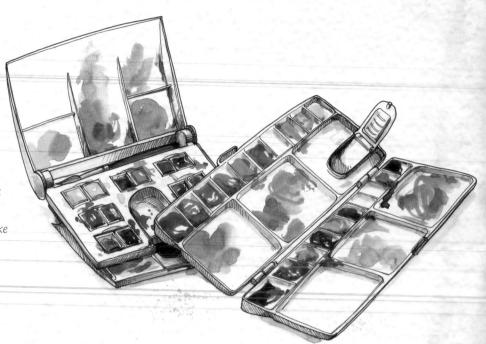

to te w

Watercolor Pencils

Although the basic technology has been around for decades, watercolor pencils have emerged only fairly recently as a viable option for serious artwork. Today, you can buy artist-quality, permanent pigments in buttery textures and intense shades. You can even get "woodless" pencils that are all water-soluble pigment except for their enameled casing. Basically, they are all watercolor pigment in dry form.

Consider trying these out with one or two open-stock pencils, or invest in a set of twelve, twenty-four or more. Choose artist-quality grade items. The old discount store pencils are weak, scratchy and dry. Try Faber-Castell's Albrecht Dürer Water-color Pencils, Derwent's in either the regular watercolor pencils or their exciting new Graphitints or Inktense Pencils or Caran d'Ache's Neocolor II Artists' Crayons.

There are a number of techniques to use with these products. You may want to check out my book Watercolor Pencil Magic, but we'll touch on some of these techniques later in this book. They're versatile, convenient, portable and especially wonderful for sketching or painting.

NOTE

You do need good paper with a tough, hard surface for use with watercolor pencils, or you'll find these pencils frustrating.

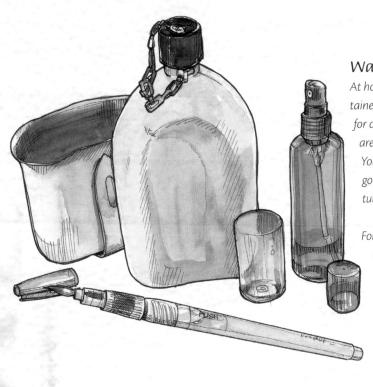

Water Containers

At home or in the studio you can use anything from a canning jar to a container made especially for watercolorists, like the double-brush tub (one side for clean water, one for sullied). Some containers include a brush-cleaning area and lid (the better to keep cat hairs out of your paint water, my dear!). You can even get a collapsible water bucket, nice for field work. Many artists go low-tech and make their own double-brush tub with a jar in a margarine tub (both filled with water).

In the field, a canteen and cup work well and are almost indestructible. For a small field sketching kit, I use a little spray bottle, plus a "cup" cut from another bottle. You can fill the cup from the bottle, then use the spray option to moisten your pan colors or paper before painting. Lately, I've been trying out Niji waterbrushes. They hold only enough water for sketching, but they work well, and there's no need to carry a separate container for water.

Other Materials and Equipment

The other items that you need depend largely on you. Here are the tools I often use—we'll see them at work later in the book.

Roll of paper towels for cleaning my palette, lifting washes and blotting excess water from my brush.

Clean cotton rags are stronger than paper towels for lifting, and not as likely to leave bits of lint.
A natural sponge for blotting, lifting and painting. (They make great organic textures!)

A man-made sponge, also for blotting, lifting and painting. These make a more even, mechanical texture.

A bamboo pen for creating a variety of linear effects and for precise scraping or incising.

A sharpened stick (or the sharpened end of a brush) for creating more organic linear effects, scraping and incising.

• A cut-up, expired credit card for scraping back washes (make a variety of sizes and shapes).

A stencil brush for spattering.

Masking fluid for protecting white paper.

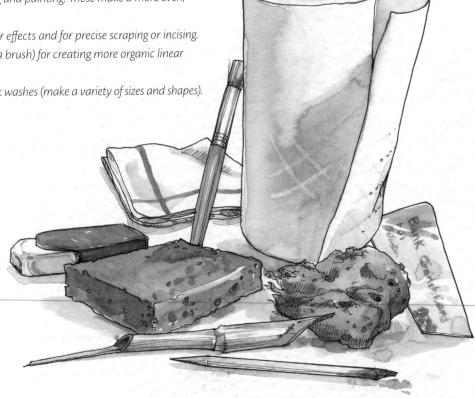

Working on the Spot—Tools for Travel

If you plan to spend much time working on the spot, you'll need a few special tools. The specific tools, again, depend on you. And, in this context, "travel" can mean to the other side of the globe or to the park down the street. Your supplies are basically the same, unless you plan to stay for a long time, far from a source of art supplies!

If you plan a full-scale painting expedition, a knapsack or messenger bag will hold your supplies, including a large container of water, a generous palette and a watercolor block at least $9" \times 12"$ (23cm \times 30cm). Add lunch and a bottle of drinking water or a thermos of coffee, and you're set!

Essentials for Sun Protection and Comfort Take along a hat for shade—just for your eyes, like the ball cap at right

or a big straw hat that will also block the glare from your paper. Sunglasses are not just good for your eyes; they also help simplify values, especially if they are polarized. Add insect repellent and sunscreen, and you're ready for the most demanding outdoor painting trip. (Though sometimes an umbrella, an extra sweater and a rain slicker come in handy.)

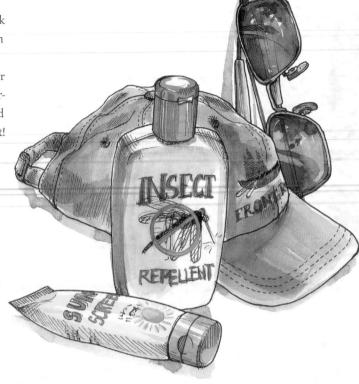

Knapsacks and Chairs

Mini-messenger bags are great for sketching trips. This little brown bag goes everywhere with me, from the classroom to country roads to crowded, noisy saloons; and it contains everything I need: a Winsor & Newton Artist's Watercolor Travel Set; a folding palette with larger pigment wells; a small water container; a tin of brushes, pencils, ink pens and a set of watercolor pencils. Throw in a few dollars, my driver's license and a credit card, and I have everything I need in one bag.

If you need a bit more comfort, and sitting on the ground isn't as much fun as it once was, consider a folding stool with a generous pocket for art supplies and so forth. Some of these stools even have backs. This one has seen a fair amount of country! You can also buy a gardening cushion or cut a rectangle from a foam camping mattress to sit on. These will keep you dry and comfortable.

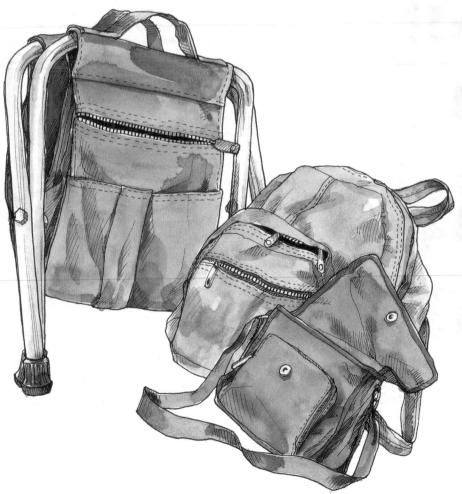

Cameras

Your camera can be anything from a small, disposable 35mm to a modern digital—whatever you're comfortable with. I prefer one with a macro capability so I can zero in on details like flowers, lichen or small insects.

You can also capture fleeting moments such as rapid changes of natural light or a scene from your car window as you streak by (only if you're not driving, of course!). Sometimes, a camera is a help if your subject doesn't have the time or patience to wait while you sit and paint. As long as we don't get caught up in trying to slavishly copy what the camera shows us, photos can be very helpful.

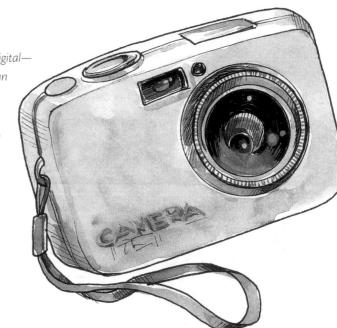

Sketch Now, Paint Later

You may not have time to do a complete painting on the spot, or you may prefer doing finished paintings back in your studio or at home, where you have controlled lighting, a comfortable chair and no bugs! In that case, you may want to make quick sketches on the spot, or even shoot photos to supplement your sketches and your original impressions.

We'll cover much more on composition, value, format and thumbnail sketches in chapter three. For now, just consider the ways you can capture your impressions with sketches or your camera.

NOTE

You may wish to invest in a small hardcover journal or sketchbook to keep everything in one place. Mine, influenced by Hannah Hinchman's wonderful A Life in Hand: Creating the Illuminated Journal, contains everything from sketches to finished drawings, from to-do lists to grocery lists. Keep everything in it! This not only makes things easier to find later; it also helps me feel less scattered.

Prepping for Mixed Media

It's not necessary to limit yourself to watercolor alone, of course. Mixed media can be very satisfying, and watercolor combines well with graphite, colored pencil and pen-and-ink. Some of these are time-honored techniques going back hundreds of years. Why not put them to work in your own paintings and sketches?

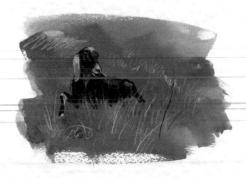

Combining Techniques

I toned the background with a loose wash of Ultramarine Blue and Burnt Sienna and allowed it to dry thoroughly, then I used black ink and white colored pencil to add the forms of the goat and the suggestion of dry grasses.

Resting

Watercolor, ink and colored pencil on Strathmore cold-pressed paper $5" \times 7"$ (13cm \times 18cm)

Combining Colored Pencil With Watercolor Washes

One of my favorite techniques for sketching and painting nature is combining wax-based colored pencils with watercolor washes.

I might add the watercolor on the spot or add it later, back at camp (or home).

Waiting helps me train my color memory.

Many of us love drawing as well as painting, and this technique lets us combine drawing and painting in strong, graphic ways.

The washes can be very quick and splashy, and the final result is very pleasing.

Rhythm of the Trees Watercolor and colored pencil on Strathmore cold-pressed paper $5" \times 7"$ (13cm \times 18cm)

Adding Ink

Dip pens allow a wonderful variety of lines (you'll need liquid ink, of course). Technical pens make crisp, uniform lines and brush pens can approximate watercolor (I find black or brown most satisfying for combining with washes).

Inks (both in bottles and pens) can be waterproof or water-soluble. Both have their place and offer a range of techniques. Colored pencils combine well with watercolor, too. You can be conservative and stick with black, gray and sepia ink, or you may branch out and use a rich indigo or burnt umber.

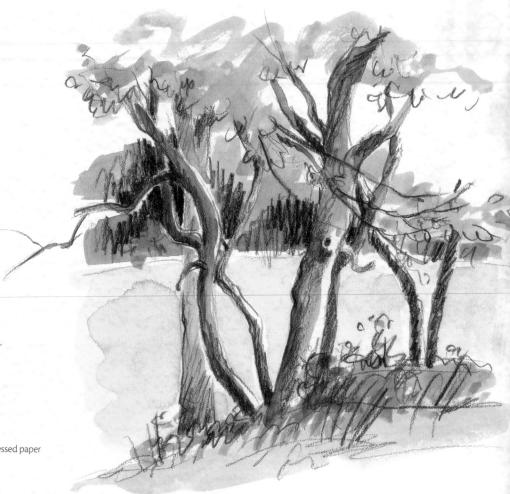

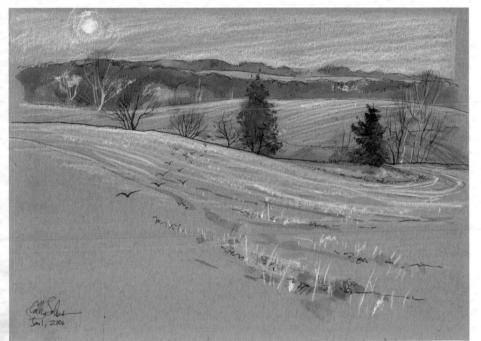

Using Toned Paper

Working on toned paper lets you experiment with an almost three-dimensional effect. You can achieve this effect by laying in the darks with watercolor and adding lights with colored pencil, gouache (opaque watercolor) or white ink, as I did in the little sketch of a goat (see page 28). Buy toned paper from your art supply store or tone your own. Either way, the effects are wonderful with watercolor.

Use whatever combination of mediums you need to get the effect you're after—there's no need to stay strictly with watercolor. Here, I chose a tan paper with a medium value. I did the initial drawing in my car, with a technical pen. Later, at home, I added colored pencil and watercolor washes to capture the image in my mind.

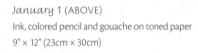

Kate's Own Greenman (LEFT)
Watercolor, acrylic, ink, leaves and acorn cap on mat board
7" × 5" (18cm × 13cm)

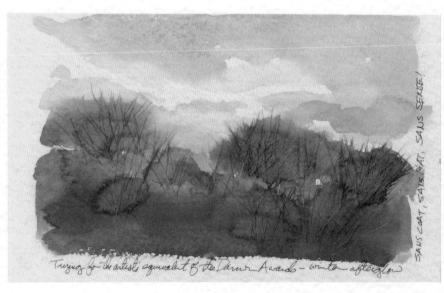

Combining Collage with Watercolor

You can even combine collage techniques with watercolor if you like. Underpaint the collaged elements, or paint right over them. It gives another dimension and new texture. (A bit of acrylic medium works well for attaching collage elements.)

Sunset Watercolor on Strathmore cold-pressed paper $5" \times 7"$ (13cm \times 18cm)

Saving Time With Toned Paper

Using toned paper can also save you time when working under adverse conditions or when you want to create a mood quickly. Here, the winter sunset was fleeting and it was cold on the porch. I grabbed the pink-toned paper to give an undertone of sunset, then laid in quick wet-in-wet washes as the darkness gathered.

CHAPTER THREE

Getting Started— The Basics

For those who are longtime watercolorists, this chapter can act as a review, a warm-up. For those newer to the medium—or to making art at all—here are some of the basic techniques you'll want to know before starting an actual painting.

Once you know the basics, you'll be able to do anything—with practice. Some artists do have a natural aptitude, of course, but we all need to hone our skills. Besides, learning new techniques and tricks is great fun—almost like magic. So, whether you're an old hand or brand-new to the medium, try these concepts on for size.

DOING A WASH

As you might have guessed, doing a wash doesn't refer to laundry. It is the basic act of getting paint to paper in whatever way works best for the effect you're after.

The process itself is simple: Dip your brush (either a flat or round) in clean water, rub it on your pigment, carry the brushload of liquid to the mixing area of your palette and rub it around a bit to mix well. Repeat until you have a nice-sized puddle of water and pigment. (If you want to mix colors, simply alternate between the two pigments until the color is right.)

The white surface of the palette will help you judge how strong or how bright your wash is, but the amount you mix up depends on how big an area you need to cover. A larger painting will need a larger wash. Judging that amount is mostly just practice, but it's better to mix too much than too little! You'll soon get the feel of it.

TIP

If you're working with moist-pan watercolor, or if the mounds of paint have dried on your palette, you may want to spray your paint with clear water to soften it and assure good, smooth mixtures.

Some artists wet their paper before the initial washes for soft, misty, wet-in-wet effects. Tape your paper to a board with masking or drafting tape, then run it under a faucet or use a sprayer. Aim for uniform wetness, then lay in your color(s), allowing water and pigment to blend on the paper surface.

Once you've finished your painting, let the paper dry thoroughly before removing the tape, or it may tear into the painted area. Pull the tape away gently and firmly at a shallow angle to the paper's surface.

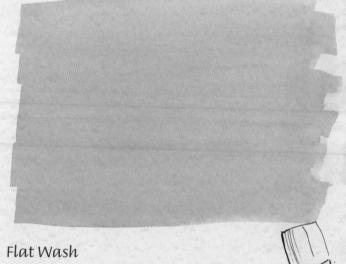

Just as the name implies, a flat wash involves putting down as flat an area of color as possible. It is most easily done on rough or cold-pressed paper (the color averages out in the little hills and valleys!).

There aren't too many times when you need a totally feature-less expanse of color, but it's good to know how to make one. Make a line across the top of the area to be painted with a brushload of your color mixture. Tip your paper a bit so that a "bead" of color collects at the bottom of the stroke. Fill your brush again, touch that line just where the bead is formed and make another, slightly overlapping stroke. Pull the bead of color downward with each stroke (gravity's a big help here!) and fill the area you need with color. Pick up the last bead of liquid with a damp brush or tissue, or you'll get backruns as it dries.

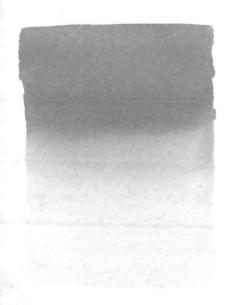

Graded Wash

This wash is made in the same way as the flat wash, but you progressively add more clear water rather than pigment. Pull the diluted wash down the page with each stroke, and it will get lighter and lighter. Again, pick up that last bead of water to prevent backruns. This wash is nice for skies and still water.

Variegated Wash

This wash is my favorite and, I believe, the most versatile. Here, you use two or more colors and mix them partly on the paper for a wonderful, exciting vibration or a subtle blending. Your brushstrokes can go every which way, with great abandon.

Two-Way Graded Wash

This wash is very similar to the graded wash, but you let the initial wash layer dry thoroughly first, then turn the paper upside down and do a wash in a different color in the other direction. (You can suggest a lovely sunset glow this way!)

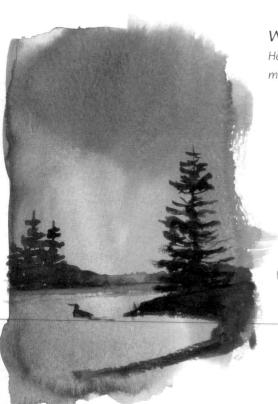

Wash Versatility

Here you can see one of the many, many ways washes can be used!

NOTE

For all but the variegated wash, some artists work back and forth across the page rather than making their strokes all in the same direction. Try it both ways!

"Flowering" Paint

This little pink blob shows how paint can run back into your wash as it dries, making a "flower" you don't want. Lift excess liquid with a brush or tissue to prevent this effect (unless you're using it intentionally, as I did in some of the illustrations for this book).

Composition and Format

In art, choosing a composition means deciding how to place things within the picture plane. There are some very simple, classic rules you can rely on, or you can break free and make new rules of your own!

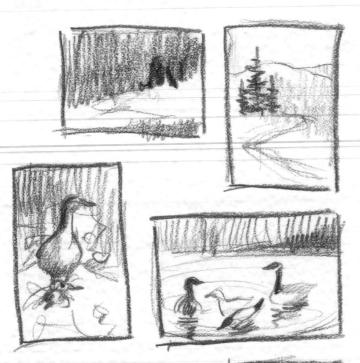

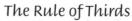

The most familiar compositional tool is the rule of thirds. Divide your paper into thirds, vertically and horizontally. One of the intersections will be a good place to put your center of interest, since the eye goes there more or less naturally. In this illustration, the little gull is perched at the intersection of the top and left lines.

You can use a variety of devices to lead the eye to that spot: curving lines, S-shaped lines, values, color. Use whatever works for you.

Thumbnails: Blueprints for Success

These tiny sketches are a big time-saver, and they'll save you paper and supplies. Take a few moments to plan out what you'd like to do and how best to handle the sometimes confusing scene before you. It isn't as overwhelming if you break it down into little "bite-sized" pieces.

You can plan format, values, composition, focus and many other elements in just a few moments with a page full of little thumbnail sketches. These can range from 1" × 3" (3cm × 8cm) to perhaps as large as 5" (13cm).

Zero in on a single subject and explore a variety of possibilities, or do half a dozen sketches in and around your locale. You may decide to focus on one aspect of the scene, or you may decide that you want a broader view, with more going on.

You can make your thumbnails in black and white (or another dark color, as I did, for more interest) or in full color. Use thumbnails to decide on a color scheme, too.

Create Curves

Look for curves that occur naturally in the outdoors, or rearrange your scene to suggest such a curve. You can use objects like the trees in this little sketch to redirect the eye back into the picture plane.

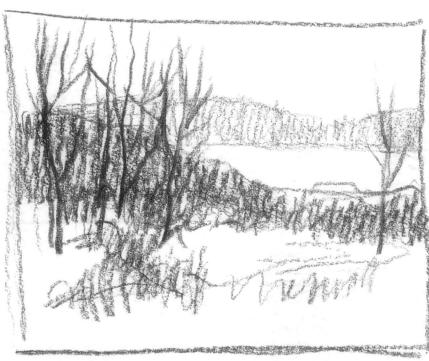

Format: Vertical or Horizontal?

Deciding on a format means determining whether your picture would work best vertically or horizontally. Try looking at the scene through a viewfinder or a little frame (an empty slide sleeve, one of the commercial viewfinders just for artists or one you've cut yourself), and see which format creates the most interesting and pleasing picture. Some formats will seem almost inevitable, but consider breaking out and doing something that focuses in a new way.

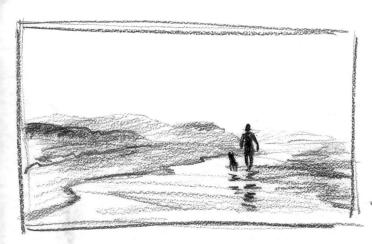

Going to Extremes

There are some exciting new sketchbooks and watercolor pads that offer an extreme format—a long, thin vertical or a broad, shallow horizontal—depending on the direction in which you choose to work. Try using one of these elongated formats to capture a mood or an aspect of your subject.

A prairie or seascape might lend itself to the wide-open horizontal, while a tall tree, mountain or even a heron might cry out for the skinny vertical format. Let your choice of format supplement the mood you're trying to create or the statement you want to make.

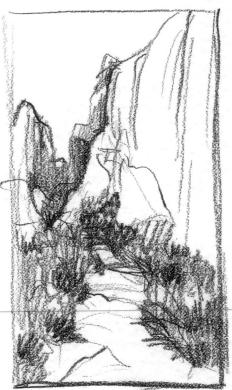

Color Choices

Color is a key to success. Think about it—we respond to some paintings instantaneously on a purely emotional level. Subject matter aside, most likely it's color that elicits that response. At a recent show I judged, one painting just made me stop and catch my breath. When I analyzed my reaction, I realized it was the artist's masterful use of color that stopped me in my tracks.

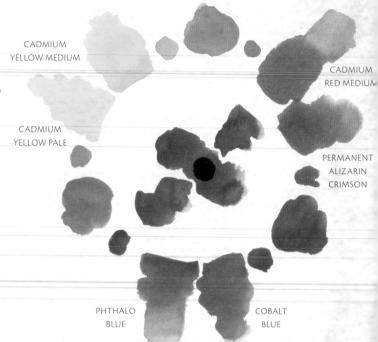

SAP GREEN PHTHALO BLUE ULTRAMARINE BLUE COBALT BLUE PYRROL SCARLET PERMANENT ALIZARIN CRIMSON CADMIUM RED MEDIUM BURNT SIENNA MEDIUM AZO YELLOW MEDIUM CADMIUM YELLOW CADMIUM ORANGE

Warm and Cool Color Wheel

To start out, try choosing one or two of each primary color in tube form. These can be squeezed out onto your palette, allowed to dry for portability then rehydrated when you're ready to paint, at home or in the field.

Using a warm and a cool of each primary color will allow you to mix clean purples, hot oranges and spring-like greens, or you will be able to choose a more subtle mixture, if you like. Mixing opposites on the color wheel (complements) will give you a range of warm and cool neutrals, depending on how you balance your mixture. Mixing all your colors produces a near-black. It's very versatile!

Test Your Colors

Some paints are opaque and some are transparent. You can use these qualities to achieve different effects. (To properly use these qualities, of course, you have to know which paint does which!) Paint a bar of India ink and allow it to dry thoroughly. Then mix a strong wash of each of your pigments and paint a horizontal bar right over the ink line. Let it dry and label your colored bars so you don't forget what you used. You'll be amazed at what you learn about the opacity and transparency of your paints. There's much more to choosing the right pigment than color.

TIP

To make mixing clean, fresh secondary colors easier, you may want a warm and a cool of each primary—for example:

- Lemon Yellow or Hansa Yellow Light (cool)
- Cadmium Yellow Medium or Transparent Yellow (warm)
- Permanent Alizarin Crimson or Quinacridone Red (cool)
- Cadmium Red Medium or Pyrrol Scarlet (warm)
- Phthalo Blue (cool)
- Ultramarine Blue (warm)

Keep It Simple

A simpler color wheel can use very pure primary colors, like Ultramarine Blue, Azo Yellow and Napthol Red. These three colors alone will produce a wide range of colors. It's a wonderful discipline to start out like this instead of investing in a full array of pigments.

The three spots of color between adjoining primaries are varied mixtures of those primaries. The arrows connect complements (yellow and purple, orange and blue, green and red). Mixing all three primaries—or mixing the complements, which is really the same thing—produces neutrals. The six outer colors are mixtures of the three primaries, in a variety of strengths.

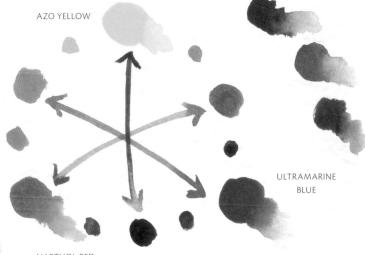

NAPTHOL RED

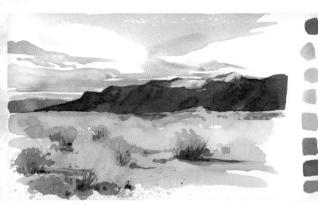

The Limited Palette in Action

It's good exercise to try a limited palette painting, that is, choosing only one to three colors for your painting. This little sketch of the Nevada desert was done on Cartiera Magnani's 4½" × 9" (11cm × 23cm) cold-pressed watercolor pad, using only Azo Yellow, Napthol Red and Ultramarine Blue. I painted swatches of the various mixtures I used on the left.

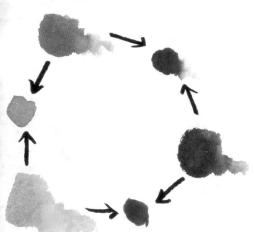

Velázquez Palette

The early Velázquez palette (named for the Spanish artist who used it so frequently) let Burnt Umber act as the red, Yellow Ochre as the yellow and black as the blue in this low-key color wheel. You may want to try the more bluish Payne's Gray as your blue.

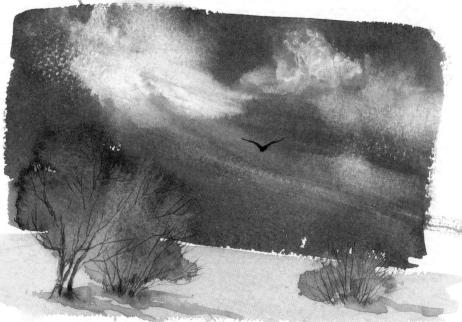

Winter Landscape Watercolor on Strathmore cold-pressed paper $5" \times 7" (13cm \times 18cm)$

Variation of the Velázquez Palette

Here I used a variation of the Velázquez palette: Payne's Gray, Burnt Sienna and Yellow Ochre. I let backruns suggest the trees and scratched the limbs into the damp wash. I lifted the clouds with a paper towel while the sky was still wet.

Values

Master watercolorist Charles Reid said, "Color gets all the credit, but values do all the work." If you have the values (the range of lights and darks) right, the colors you use don't matter all that much.

Whether you choose a high-key palette or a dark and moody one, you'll find that values give you a solid foundation to build on, and they'll get the idea across in the strongest possible way.

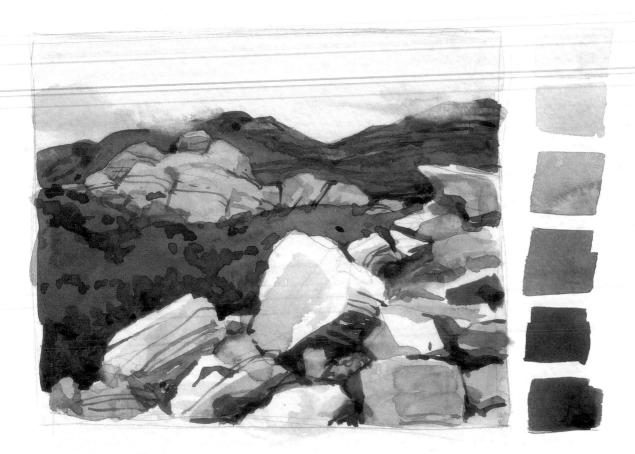

Values Experiment

Try making strokes or blobs of values from your darkest dark to lightest light (use a neutral or a color). Then see how these can give your artwork depth and interest.

High Key

This little sketch is high key, using predominately light values. It captures the sunny effect of Nevada's desert in a way that would be difficult with darker, heavier colors.

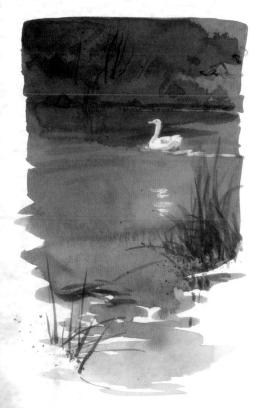

Low Key

This low-key scheme, using the darker value range, lets you know it's late in the evening, when objects become flatter and less distinct. The white goose really stands out against the deep shadows of the far bank. This image has a serene feeling that would not have come across if I'd chosen a high-key palette.

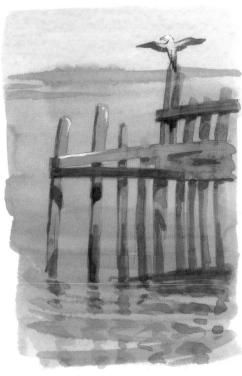

Medium Key

Using colors that are medium in key and close in value produces a foggy look that suits subjects such as this old wooden pier in Maine.

Moody Colors

Choose your colors to create a mood—cool blues feel like winter; yellows, oranges and reds feel hot and subdued; blues and greens suggest a cool, overcast day. Your colors can suggest serenity, energy, passion or peace. Think about the effect you want before choosing your palette.

Emphasize what you see before you, or create a whole new color scheme to fit the mood you want. No one says you have to paint exactly what you see.

This plein air painting was done on a cloudy day in spring, with blue, hazy skies and cool, green fields.

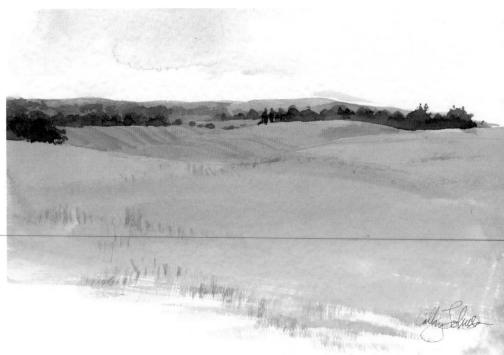

Across the Road Watercolor on Strathmore cold-pressed paper 9" \times 12" (23cm \times 30cm)

CHAPTER FOUR

Into the Woods-Forest Habitat

o matter where you go—unless you're above the tree line, in the tundra or in the driest of deserts—you're going to find trees of one sort or another. In winter, they are bare ink-line limbs against the sky, or they huddle in their evergreen coats. In spring, they burst out with pale green buds and some with flowers. Heavy with leaf, nut and fruit in summer, or flaming as though lit from within in autumn, trees are our largest plants, and they're always a challenge and a joy to paint and draw.

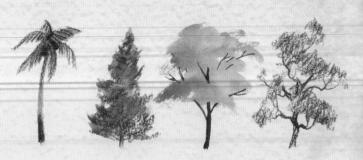

Find the Right Medium

Try out different mediums to see which works best with your subject, mood or situation. Here, from left, the palm tree is done with Derwent's new Inktense watercolor pencils, the cedar is Derwent's Graphitint watercolor pencils, the elm is watercolor and the oak is colored pencil. Use your drawing or painting tools to suggest the type of foliage—linear marks for the palm fronds, tight scribbles on the cedar, etc.

Variations Make a Difference

Even when you paint massed trees in the distance, as I did here, you'll need some variation in shape and color to get the idea across. Suggest the shadows between the trees, the varied shapes of their crowns or different colors.

Shenandoah Watercolor on Strathmore cold-pressed paper

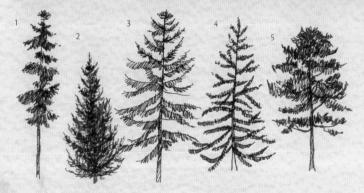

Shape Up

Even trees you think might have a common shape, don't necessarily. Consider evergreens. They're not all conical. Here, you see silhouettes of (1) a towering, narrow Eastern white pine, (2) a dense balsam fir, (3) a conical Norway spruce, (4) a very open Douglas fir and (5) an oval shortleaf pine.

9" × 12" (23cm × 30cm)

Tracking the Seasons

If you live in an area where trees lose their leaves in winter or turn bright oranges, reds, golds and russets in the fall, you've got a lot of material to work with. Try out different ways to capture these changes, or choose a single tree and paint it, season after season, to understand its life cycle.

Fall Glory

One year, in the new Missouri Department of Conservation holdings at Cooley Lake, everything turned gold. There were a few spots of red here and there, but it was like being in a space made of tangible sunshine. Glorious! My quick sketch captures some of that glory.

A varied underglaze can set the mood for your painting. In this case, I quickly covered almost the whole surface of my small watercolor block with a glaze made from Cadmium Yellow Medium and Transparent Yellow, with just a bit of Phthalo Blue and Cadmium Red Medium to provide a hint of autumnal variation. Then, I added tree shapes and other details.

Gold Forest

Watercolor on Strathmore cold-pressed paper $5" \times 7"$ (13cm \times 18cm)

Spring Growth

Take the opportunity to track spring as well. A simple pencil sketch of a tree bud will capture the burgeoning rebirth of the year's cycle.

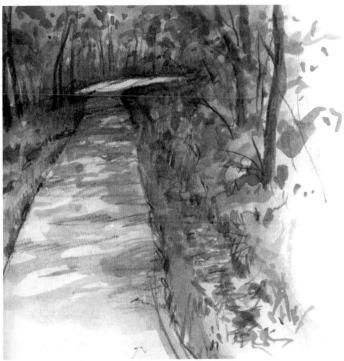

Capturing Summer Greens

Sometimes it seems as if summer is just one unbroken shade of green, but, if you pay attention and look carefully, you'll see a wide range from light yellow-greens where the sun shines through the leaves to deep, shadowy blue-greens. Layering can help you capture the stained-glass effect of a deep summer forest.

Watkins Path Graphite and watercolor on Pentalic journal paper 6" \times 6" (15cm \times 15cm)

Revealing Winter

Winter gives us a chance to really see the bones of a tree: how it's constructed, how the trunk narrows to branches and then to limbs and twigs. Make some limbs appear to come toward you with foreshortening and push others back with overlapping shadow or less detail to give a sense of overall volume.

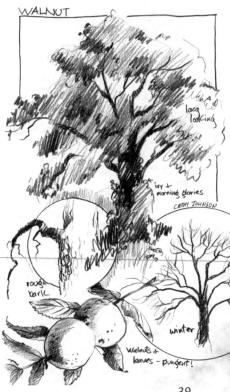

Trees From a Distance

You won't see individual trees from root to crown when they are massed in a distant land-scape, but you may still need to suggest that this is a forest made up of many different trees, not a single organism. There are almost as many ways of doing this as there are artists, but here's one that works quite simply.

MATERIALS

SURFACE

Fabriano hot-pressed paper

PIGMENTS

Burnt Sienna, Cadmium Yellow Medium, Cobalt Blue, Phthalo Blue, Yellow Ochre

BRUSHES

 $\frac{1}{2}$ -inch (13mm) flat nos. 3 and 7 round

OTHER SUPPLIES

mechanical pencil

Begin by laying in the basic shape of the forest's foliage mass, allowing for some variation in edge, color and shape to suggest different individual trees. (If you want to suggest some lighter trunks or branches, you can mask them out before painting or lift them with a damp brush and clean water.) Let your brush dance along the edges to give a lacy, foliage-like effect.

Drop in color at this point to make wet-inwet areas of shadow or varying color. Let this dry thoroughly. I used a mixture of Cadmium Yellow Medium and Phthalo Blue, mixing in a heavier amount of yellow for the right side. I used Yellow Ochre for the right bank.

2 Build Volume Suggest some shadow

Suggest some shadow shapes to give the trees in your forest volume. Use a darker shade of the color you've mixed from Phthalo Blue and Cadmium Yellow Medium or a wash of cool Phthalo Blue. The shadow shapes can have lacy brush marks at their edges, too.

name Paint the Limbs and Trunks

Let the shadows dry. Paint a few limbs or trunks within these dark shapes using Burnt Sienna and Cobalt Blue, and add little bare twigs at the edges. You can suggest a bit of detail by drawing back into a damp wash with the tip of a sharp mechanical pencil. It will bruise the fiber of the paper, making it take the pigment more deeply. You're not so much drawing graphite lines as making the paper respond differently when it's wet.

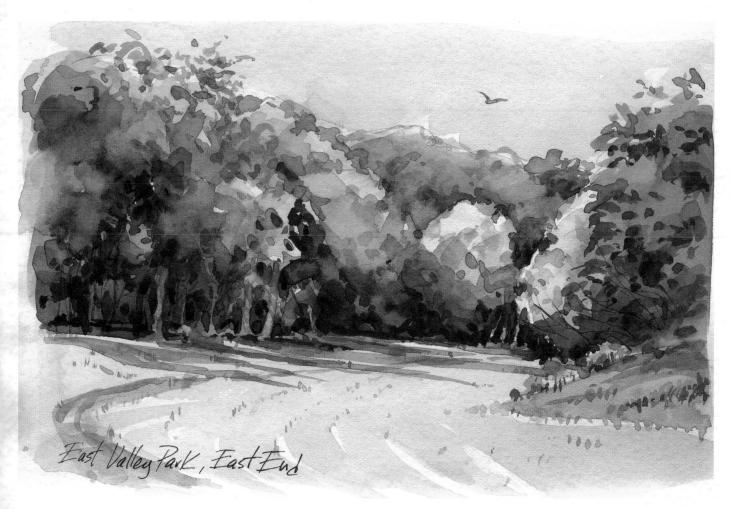

East Valley Park, East End Watercolor on Fabriano hot-pressed paper 5" x 7" (13cm × 18cm)

Refine the Shadows

After I got home, I refined the shadows a bit and added more suggestions of lacy foliage. I watched for the negative shapes and added deeper glazes of color to suggest these shadowy areas. Phthalo Blue and Burnt Sienna make a wonderful deep green. Small squiggles and dots suggest foliage.

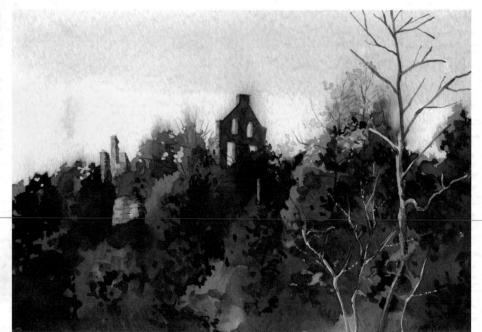

Another Option: Add Complexity

If you want more complexity, first use masking liquid to preserve some light-struck, lacy leaves and lighter branches, as I did here. Then proceed more or less as before. Allow everything to dry, and remove the mask.

You'll have hard edges where the mask was, so you'll want to soften them with a brush dampened in clear water. Scrub here and there and lift the loosened pigment with a tissue. Then, using a small brush, add color and any details you wish.

Hill Castle
Watercolor on Strathmore cold-pressed paper $9" \times 12" (23cm \times 30cm)$

Leaves and Tree Bark

If a tree is the main subject of your painting, the leaves and bark will be an important part of your work. These elements are as varied as the species of tree. There are many different kinds, shapes and configurations of leaves, from the simple canoe shape of the elm's leaves to the mulberry's mittenshaped leaves to the fern-like leaves of walnuts and ash.

Bark Patterns

Take a look at how different these bark patterns are. If you wanted to draw a specific tree with its growing pattern and shape, it would be best to at least suggest something of its bark. Above, you can see how different a box elder is (left) from a silver maple (right).

The bark of younger trees is generally smoother than that of older trees. That's because part of what makes the distinctive ridges and plates is the growth of the tree itself.

Know Your Bark

Some trees have deep, rugged grooves in their bark. Some trees have long, relatively thin peeling bark (that's why they call it "shagbark" hickory). Some have shiny bark that looks as though it were stretched over the tree. Some trees have bark that is dark and gray. Others, like sycamore and paper birch, are almost pure white in places. Because these trees grow in different habitats, painting them correctly will give your work a real sense of place. Here you can see the bark and leaves of the walnut (far left) and wild cherry (left).

Easy As 1-2-3

You can simplify painting tree bark to an easy three-step progression. First, lay down a variegated wash, keeping it cooler on the shadowed side. Let that dry, and then add sharp details of shadows and crevices. Allow that to dry, and add warm and cool shadows (these will help integrate the crisp lines you've laid down in step 2). This illustration is of the peeling bark of the maple tree in my backyard.

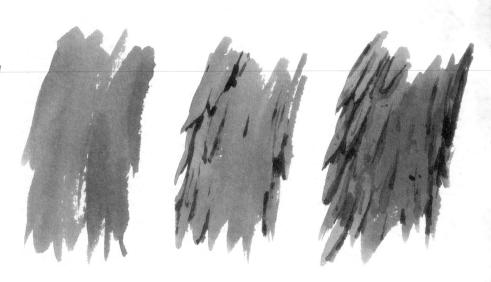

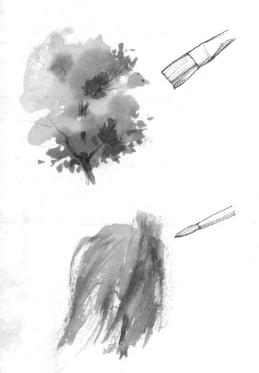

Variegated Washes

A flat brush is very handy for laying in large, variegated washes. Make multiple dots and dashes with one corner of the brush to suggest the smaller clumps of leaves at the edges, as shown.

Drybrushing with a round brush creates a linear effect that says "weeping willow."

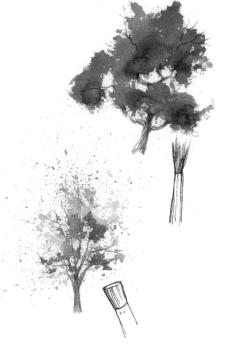

Loose, Open Foliage

A ratty old oil brush is great for loose, open foliage. Use a pouncing stroke with just the tip, and be sure to suggest lights and shadows.

You can spatter on an open effect with an old stencil brush. You may want to cut or tear a mask out of paper to spatter through so you don't get droplets all over your painting. Blot here and there with a clean tissue for variation, then add limbs.

Sponge

A natural sponge can be a wonderful painting tool. I tore a small piece from a particularly raggedy sponge and used it to paint both of these small trees. For the top one, I used a pouncing motion, dabbing repeatedly into a puddle of paint and then onto my watercolor paper.

In the lower example, I used quick, sweeping motions, following the shape of the evergreen tree. I then made the connecting branches by dragging the wet paint out with a pointed stick.

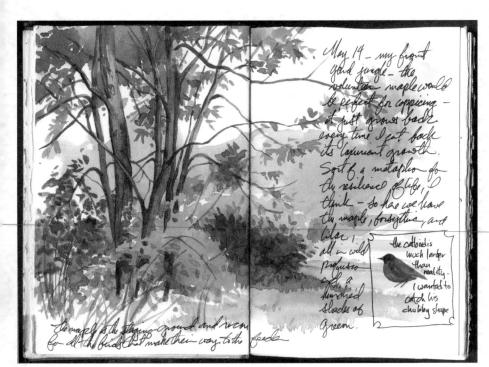

Experiment

Use your journal to try out various ways of painting foliage. Try quick, dancing strokes, massed shapes, variegated washes and single strokes to suggest leaves at the edges. Be sure to notice the variation in color.

Denizens of the Forest—Plants and Creatures

One of the lovely things about spending time in the woods is that you can look around and see things you might not notice otherwise. Small wildflowers at your feet bring your attention to a patch of unexpected color, a complex and ornate flower in early spring or the rough-and-tumble of late summer's tall golden flowers. They're all worth sketching and painting.

If you're quiet when you go into the woods, you're liable to see wildlife as well as flora and fauna. Be still and quiet, and they'll accept you—albeit warily—and go back to their normal life. Squirrels may scold from behind a branch. Birds resume their song, feeding and mating and nesting all around you. Butterflies and moths flit by, without a care. Watch for graceful lunas and the amazing camouflage Io moths, who flash large "eyes" at would-be predators.

Nature's Beauty

Different flowers bloom in different areas, of course, depending on your latitude and longitude, weather, soil type and elevation. The beautiful, modest coral-colored columbine in my woods is nothing like the huge skyblue versions in the evergreen forests of Colorado's Rocky Mountains.

The light was fading and I was hanging onto the side of a steep bluff as I tried to capture this pretty bellwort, but I painted as much as I could.

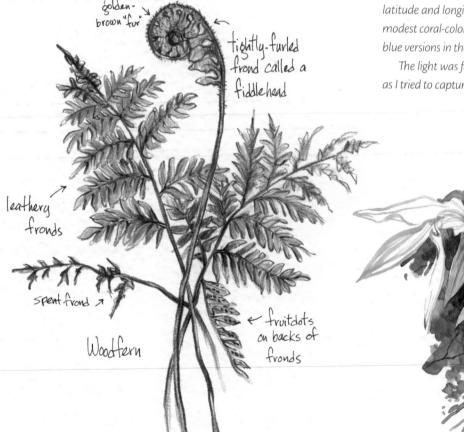

Add Detail Later I added some detail and tightened up the sketch a bit after I got back home.

Fern Fun

Ferns and mushrooms are fun to paint and draw. Look around as you hike or ramble, or just sit for a while and let the forest show itself to you. You may see something you'd normally overlook.

Here's a quick technique for sketching in nature: Do the basic drawing with a wax-based colored pencil (I used black here). Then use watercolor pencils or watercolor washes to splash in some color.

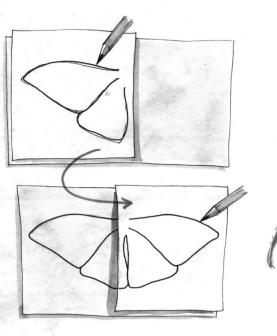

Butterfly and Moth Proportions

A quick sketch will help you get proportions right. If you need to, you can draw one side of the butterfly or moth, then lay a piece of tracing paper over that half, trace it and flip the tracing over to make sure the other side is symmetrical.

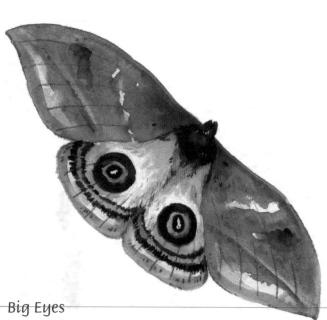

The Io moth comes in several shades. Some have very dark upper wings, and some are bright golden yellow, but the underwings are always a surprise when they "open" those eyes at you.

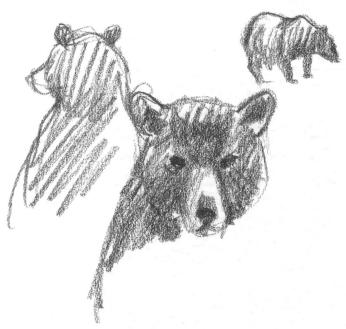

Binoculars Are Best

In your wanderings, you might even see a bear (they're becoming more common in many states). In that case, though, I don't suggest a close-up study. Binoculars are good when the animal is a large predator. A quick sketch to finish at home may be your best bet. You can always work from your drawing or just splash on a quick watercolor wash.

Birds

One species or another, birds are everywhere. In the woods near my home in Missouri, I see robins, cardinals, jays, titmice, chickadees, wrens, goldfinches, sapsuckers, a variety of woodpeckers, owls and more. Every once in a while, I even see a hermit thrush. Unlike many mammals, birds are seen even in towns and cities. Some will come right to your feeder to model for you.

Speedy Sketching

Birds move fast, so you need to be ready. Just make a quick sketch like this to capture the basic shape. You can fill in the details later, from memory.

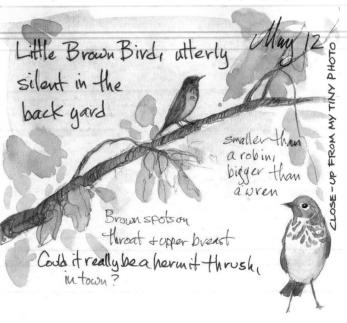

Journal Detective Work

Use your journal to study the wildlife around you. I did this rough sketch of a mystery bird and added written notes. Later, I was able to identify it as probably a hermit thrush, so I did a more complete illustration on the same page.

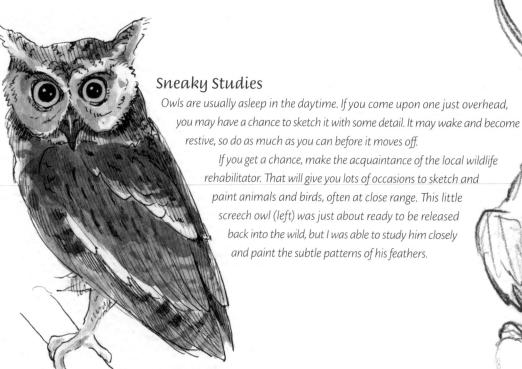

Weston Bend

It's interesting to approach a familiar subject from a different vantage point. Here, we're looking through the dark foreground trees, with all their sharp detail, to the soft, sunlit Missouri River valley far below. It was a trick suggesting that sense of distance.

MATERIALS

SURFACE

Strathmore cold-pressed watercolor block

PIGMENTS

Burnt Sienna, Cobalt Blue, Manganese Blue Hue, Phthalo Blue, Transparent Yellow, Ultramarine Blue, Yellow Ochre

BRUSHES

34-inch (19mm) flat no. 5 round with sharpened end

Partner Up

It's fun to go plein air painting with a partner. Here's Joseph Ruckman (my partner in every way!), at Weston Bend State Park in northwest Missouri.

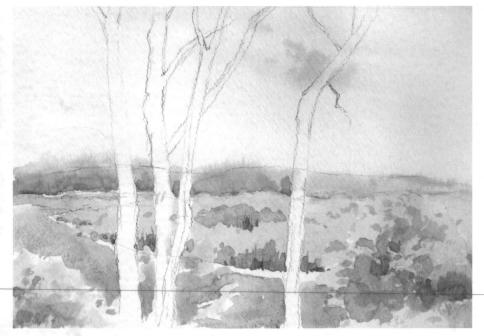

Start With Tree Shapes

The tree shapes and the spaces between them are important so sketch them in first, then lay in the sky and far hills using Manganese Blue Hue and some Cobalt Blue. Allow the deeper blue of the hills to bleed up into the sky so there will be no sharp demarcation—it helps push them into the distance. When that's dry, add the wooded valley, mixing your greens with Phthalo Blue and Transparent Yellow. Next, for the river, use a stronger mixture using Manganese Blue hue, Transparent Yellow and a bit of Yellow Ochre. I love the way the settling colors suggest a muddy old river. Finally, add the suggestion of shadows and tree crowns using a richer mix of Phthalo Blue and Transparent Yellow with a bit of Burnt Sienna.

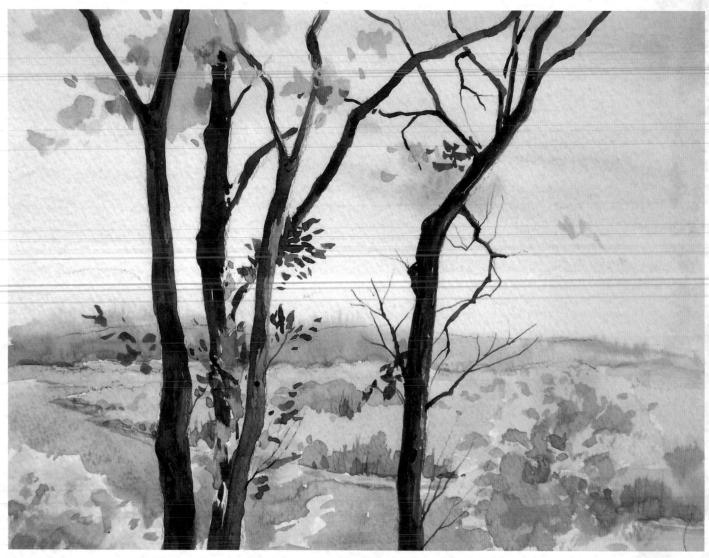

Define Trunks and LeavesPaint the trunks with a no. 5 round and a strong mixture of Burnt Sienna and Ultramarine Blue to make a lovely deep gray. Scratch the suggestion of bark into the trunks, using the sharpened end of a brush. Use the same sharpened brush to dip into a puddle of paint to delineate the small limbs and twigs. Begin to add the leaves using a small brush and a strong mixture of Phthalo Blue and Transparent Yellow, with a bit of Burnt Sienna added to make a really deep green.

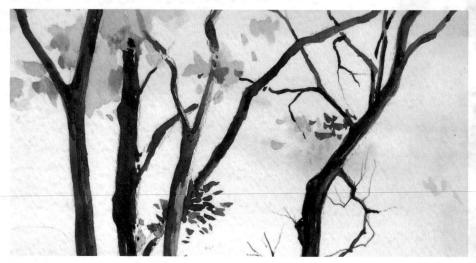

A Closer Look

This detail lets you see the rich greens possible with a mixture of Phthalo Blue and Burnt Sienna. Note how simple the leaf shapes actually are—just quick touches with the tip of a round brush.

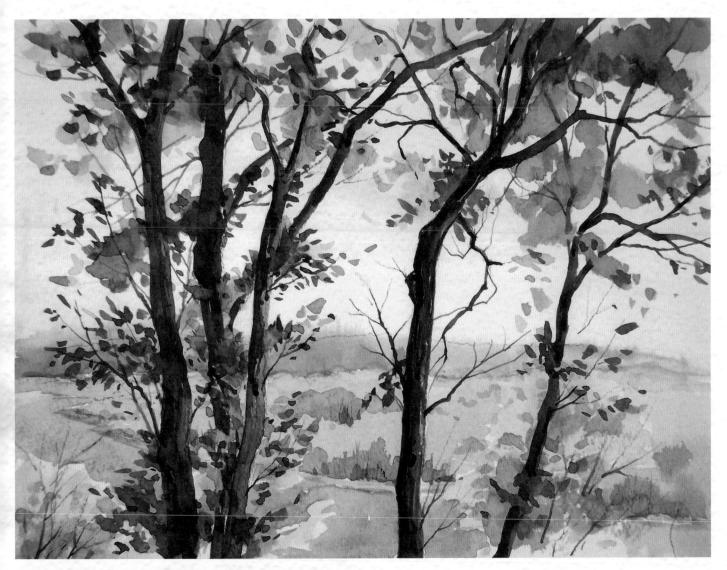

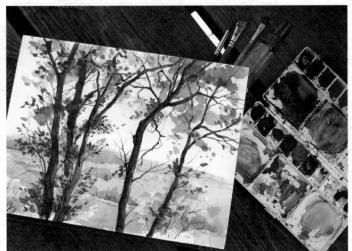

3 Add Twigs and Details
Sometimes I think it's a good thing we get tired, working outdoors on the spot. It's easy to get lost in all the detail and overwork our painting. I hope I stopped in time with this one. The limbs and twigs were so intriguing. I used one of my favorite tools to make the small twigs—the end of a wooden-handled brush that I had sharpened with a pencil sharpener. Dip in a strong wash of Ultramarine Blue and Burnt Sienna, and then drawn onto the paper. The sharp point makes delicate, believable twigs. Quick, small dabs suggest lacy leaves.

View From Weston Bend's Overlook Watercolor on Strathmore cold-pressed paper 9" × 12" (23cm × 30cm)

Take a Step Back Here you can see the finished painting with some of my gear on the shady bench. Stepping back from your work lets you get a bit of perspective and evaluate where you need to go next—if anywhere! I liked how the twigs and leaves looked and decided this was finished.

CHAPTER FIVE

By the Water

ater is one of the most beautiful, intriguing, challenging and magnetic of subjects for the artist. And, it's naturally suited, of course, to being rendered in watercolor. Reflective and still or moving in patterns determined by winds, rocks, elevation or the pull of the moon on tides, water calls to us to try to capture its quicksilver beauty.

Depicting water is an endless challenge given all the variables and circumstances, but it needn't be an impossible one. You can even employ a kind of shorthand to indicate water, using pure watercolor or combining it with other mediums.

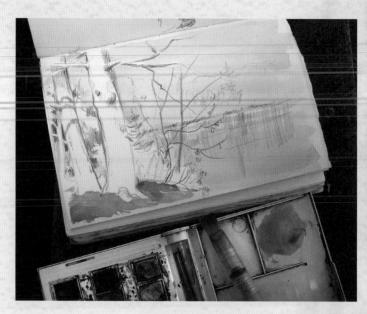

Adirondack Camp
Watercolor and colored pencil on Fabriano cold-pressed paper
5" x 7" (13cm x 18cm)

Indigo Magic

Indigo colored pencil provided the framework for this multimedia sketch. It's one of my favorite tricks for depicting water. The vertical strokes near the shore suggest reflections, and the horizontal strokes in the water make it look limpid and wet. It's magic. You can see the first washes in this on-the-spot photo as well as some of my tools.

Finish With Washes

A succession of quick watercolor washes finishes the scene. I worked wet-on-dry, letting the first washes dry thoroughly before adding more. Leaving some horizontal areas of untouched white paper gives them the sparkle that reads as water, too.

Still Water—Lakes, Ponds, Coves, Marshes

It might seem that this is the easiest type of water to paint, and perhaps it is. Still, there are some tips and things to watch out for. The way your body of water looks depends on a lot of factors. How far away are you? Close up, near a shoreline, in a still cove or on a pond, you'll find reflections can play a big part in capturing the "look" of water and adding to the overall composition. At a distance, especially on a cloudy or rainy day, reflections may not be very visible if they show up at all (see image below).

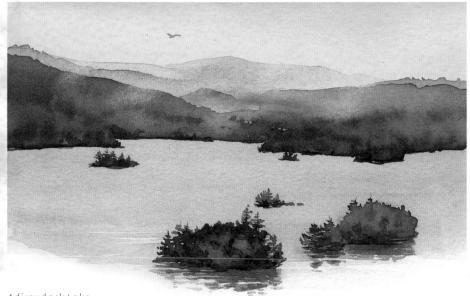

Adirondack Lake Watercolor on Fabriano hot-pressed paper

5" × 7" (13cm × 18cm)

Rainy Reflections

This was painted from a window table in the Adirondack Museum's café on a very rainy day. You can see the reflections of the nearest islands, but, in the distance, the lake appears almost featureless. I used a smooth wash for the water and the cloudy sky, lifting here and there in the sky to suggest the low clouds. In the water, I paid close attention to the reflections of the little islands. I painted them with a small round brush, letting my brush dance along the edge nearest the viewer to give the impression of reflections broken by wave action.

The colors used for the reflections were a lighter mixture of the ones used in the islands themselves, which were mainly Phthalo Blue and Burnt Sienna.

Level Horizons

Notice, when painting a body of water like a pond, lake or even the ocean, that the distant water almost always looks flat and straight. Unless you're trying to paint a wild storm in the ocean, as Winslow Homer often did, the horizon line (or the distant shoreline) should be level.

The shore or coves closer to you may have more shape to them, as you see in this painting of a red canoe on New York's Lake Durant, but the water farthest away appears flat.

Red Canne Watercolor on Strathmore cold-pressed paper 9" × 12" (23cm × 30cm)

Maine Coast Morning

This beautiful estuary near Port Clyde, Maine, is the mouth of a tidal river, where salt water mixes with fresh water with each incoming tide. The distant house and its outbuildings were so inviting in the early morning light that I had to paint the scene. The water was wonderfully still and reflective, catching and holding the sunlight and cloud shadows.

MATERIALS

SURFACE

Fabriano cold-pressed watercolor block

PIGMENTS

Burnt Sienna, Cadmium Red Medium, Cadmium Yellow Medium, Cobalt Blue, Phthalo Blue, Ultramarine Blue

BRUSHES

1-inch (25mm) flat nos. 3 and 10 round

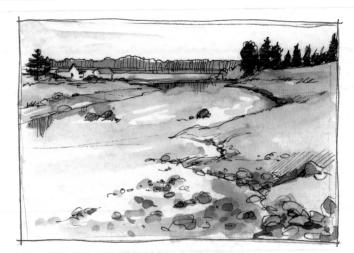

Small Reference

This tiny sketch helped me plan the painting. I was able to decide on the horizontal format as well as what I wanted to include and what I should leave out.

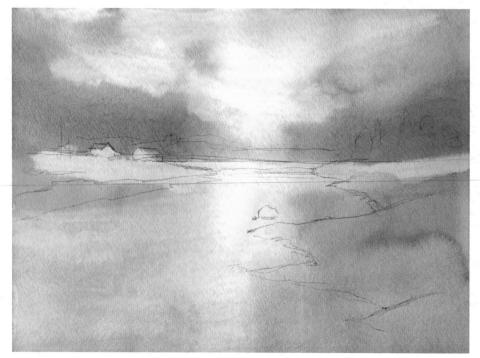

Lay in the First Washes

On a simple pencil sketch, lay in the first wet-in-wet washes, using a large 1-inch (25mm) flat and fresh mixtures of Cobalt Blue, Phthalo Blue and Cadmium Yellow Medium. While that is still wet, lay in the clouds and fog bank with a mixture of Ultramarine Blue and Burnt Sienna, concentrating the darkest area close to the land.

Lift the areas of lightstruck clouds and water as well as the white buildings and the land the buildings are on. In my painting, I wanted a purer, cleaner, sunstruck green. Use the edge of a folded paper towel to get into the shapes of the buildings with some accuracy.

These washes should dry with a few hard edges and "flowers," but they'll be covered with subsequent washes, so don't worry about it.

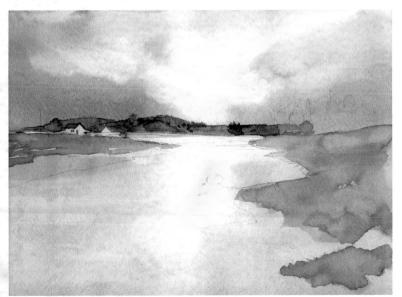

2 Enhance Trees, Grass and Buildings
Using a medium value of Phthalo Blue and Burnt Sienna, mixed, suggest the trees on the far shore, with intentional "flowers" of wetter paint here and there to give the illusion of a variety of tree shapes.

Phthalo Blue and Cadmium Yellow Medium make the nice rich green for the grassy shorelines. A no. 10 round works well in these areas. Encourage some variation in value as you go along.

The red roofs help to define the buildings' strong architectural shapes, even at a distance. Use a mixture of Cadmium Red Medium and Burnt Sienna, applied with a no. 3 round. It's important to get shapes like this down accurately. I held my breath while I painted them!

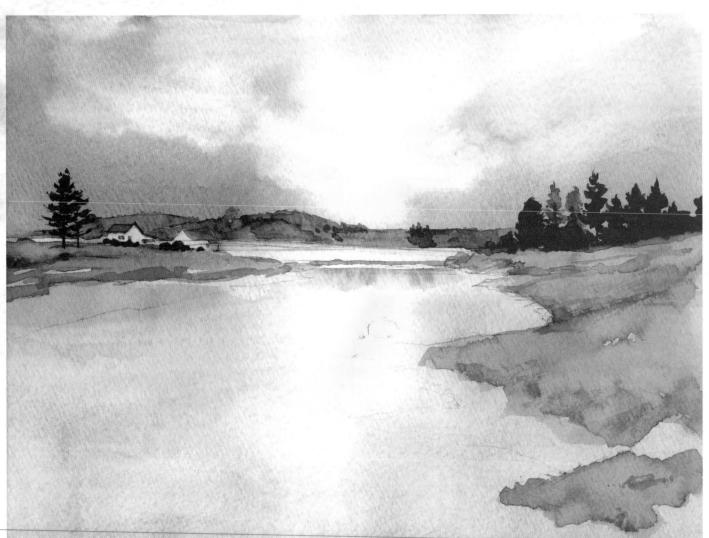

Paint the Distant TreesUse a very strong, rich mixture of Phthalo Blue and Burnt Sienna for the distant evergreens.
A dancing touch with the tip of a no. 3 round will capture their lacy shapes, even at a distance. Use darker mixtures of Phthalo Blue and Cadmium Yellow Medium to shape the grassy areas, giving them form and roundness.

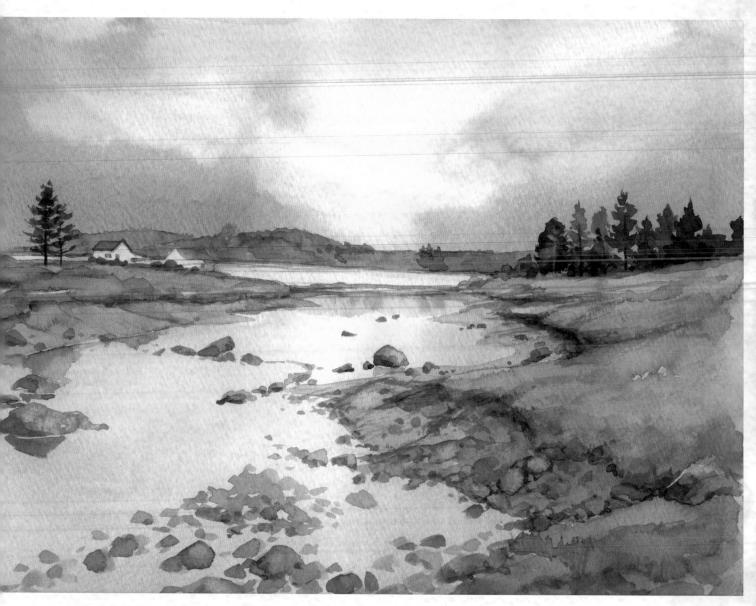

Maine Coast Morning, Early Watercolor on Fabriano cold-pressed paper $9" \times 12" (23cm \times 30cm)$

Paint the Shoreline and Rocks

The shoreline and rocks, exposed at low tide, are a mix of Burnt Sienna and Ultramarine Blue, leaning more toward the warmer brown. Paint them wet-on-dry for maximum control, and add the reflections of the trees and rocks judiciously and simply.

Important Details

It's good to sketch some of the details you find near your primary subject, though they may never find their way into a finished work. Your understanding of the subject becomes much deeper when you pay attention to the small things that make a place unique. Exposed by the low tide near this estuary, I found a mussel shell with a live barnacle in it and couldn't resist a quick sketch.

Reflections and Wave Patterns

Painting reflections can give a lot of life to your work. They really say "water!" Keep it simple or go as complex as you choose, but pay attention to the fundamentals. Generally speaking, a reflection is darker and sharper closer to its object, particularly if you are painting a close-up. A reflection gets lighter and less like what it reflects as it gets farther from the object and closer to the viewer.

Angling Reflections

Keep the angle of the reflection roughly the same as the object (remember that it will angle in the opposite direction since it is a mirror image). Try placing a mirror flat on a table, then stand a pencil up straight on top. It looks like one continuous line. Angle the pencil to the right or left and you see that its reflection leans the same way, at the same angle to the mirror's surface. Factor in the natural variations of wavelets that you usually see in water, and you're there!

Notice the angle of the reflection on the left—that's how it should be. Now look at the one on the right. You can see that something's just not quite right!

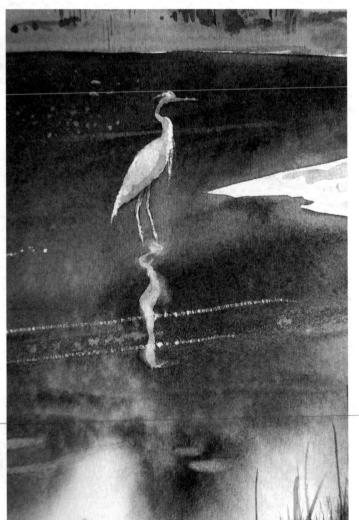

Light Reflections

Plan ahead when painting the reflection of a lighter object. Mask out the shape of the egret and its reflection with liquid mask and allow to dry thoroughly.

Paint the water with a bit of clear water spattered in to give it sparkle (the droplets push some of the pigment out of the way where they land). When that is thoroughly dry, remove the mask. Lift an edge with a bit of India rubber, and pull the rest away gently.

Paint the egret with a small, round watercolor brush and a pale wash of Cobalt Blue to suggest the shadows on this pure white bird. Add a bit of Burnt Sienna for the bill and legs. Use a sharp craft knife to scratch in the long, plume-like feathers on the big bird's head and chest.

The reflection needs to be less distinct than the bird itself. Remove the mask and soften the edges with clear water and a small, stiff brush, blotting up most of the loosened pigment. Flood in a suggestion of the same blue used for the bird, and let everything dry. Use a craft knife to scratch a couple of long, horizontal sparkles across the water and the reflection.

Mosby Lake Heron (detail) Watercolor on Fabriano cold-pressed paper 22" × 15" (56cm × 38cm)

Other Reflections

In this little watercolor sketch, I first laid in a light Phthalo Blue graded wash for the water with a ¾-inch (19mm) flat. I made the wash darker in value near the bottom of the page by adding a bit more pigment to my wash as I pulled it down the page. After allowing it to dry, I added the reflection of the trees on the shore across the cove. You can't see the trees, but you know they're there from the reflection.

I used dry-brush strokes on the closer edge to suggest the sparkle of light on water and painted a few ripples using the same strong mixture of Phthalo Blue and Burnt Sienna. Then, using the wet-in-wet method, I added a lighter green made up of Phthalo Blue and Transparent Yellow and let it blend and flow to suggest trees of varying colors on the invisible bank.

Meanwhile, I laid in the first small, simple washes to begin suggesting Leslie in her bright yellow and red kayak. I laid in some of the reflections at the same time so that the colors could blend—that keeps them from looking pasted on.

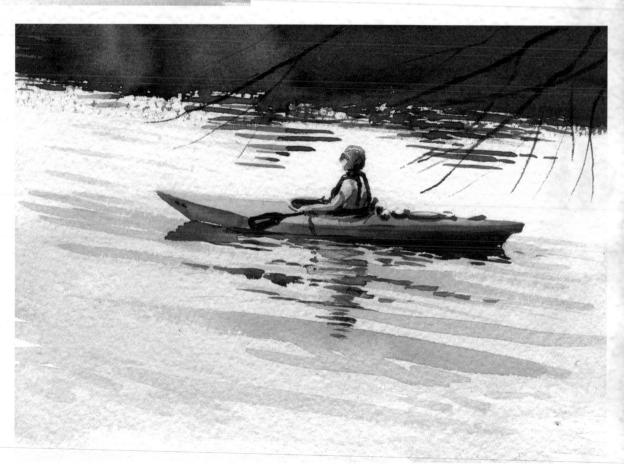

Leslie in the Afternoon Watercolor on cold-pressed paper 4" \times 6" (10cm \times 15cm)

Finishing Touches

I let those first washes dry and went back in to finish the darker shapes of shadows, paddle, life vest, sunglasses and other details, mostly using a rich mixture of Ultramarine Blue and Burnt Sienna and a small, round brush.

I added a stronger mix of the same blue I used in the water to suggest the wave patterns. Then I added a few more details in the reflection as well as the bare branches reaching into the picture from the upper right. It's a tiny painting, but it has a sense of life and motion.

Fast-Moving Water—Rivers and Streams

Painting fast-moving water is a different kind of challenge, but don't let it scare you. All you need to do is sit and look long enough so you can discern the patterns. Just as rocks and tree limbs breaking the surface of the water cause disturbances, so do submerged rocks and limbs. Depending on the elevation (the steepness of the fall), you may see more or less white water. Reflections appear only in the slower moving water or still pools. Often as not, they just show as a rich glow of color, without any detail.

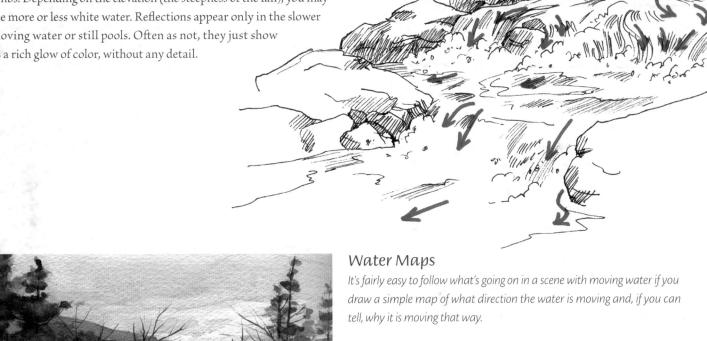

Light Difficulties

Painting this scene on the spot in the Elizabeth Furnace Recreation Area was a real challenge. The light changed almost as frequently as the shapes in the water. Eventually, I was able to discern what caused the water patterns and simplify them. Rocks just under the water's surface made subtle shapes of light and dark, while those that broke the surface made a more broken, lacy pattern.

I allowed granulating pigments and intentional hard edges within the mountain's bulk to suggest the richly forested slopes. I kept the rest of the trees simple, so most of the focus would be on that sparkling, moving water. Rapid, calligraphic brushwork with minimal detail worked well for the mountain stream.

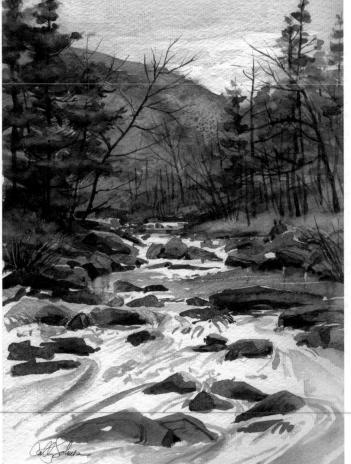

Elizabeth Furnace Watercolor on Fabriano cold-pressed paper 12" \times 9" (30cm \times 23cm)

Ocean Habitat—Tidal Zones and the Seashore

Sketch whatever catches your eye—seashells, coral, seabirds. These elements capture the essence of this unique habitat. They may or may not find their way into your painting, but they will enhance your understanding of the big picture.

Ocean-Side Plants

Pay attention to the unusual plants that are unique to this habitat. A quick sketch will suffice.

Sketching on the Spot

These waves were at California's Ocean Beach. I did the quick ink drawing in my journal by observing the repeated patterns of the waves rather than trying to do a portrait of a specific set of breakers as you might when working from a photograph. I added the color later, from memory.

Ubiquitous Flyers

Near the ocean, gulls of one sort or another are everywhere. (They also congregate on inland waters. I see them on the lake near my home in the Midwest.)

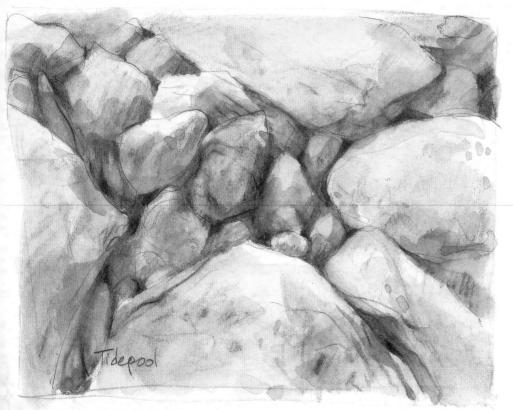

Watercolor Pencil Benefits

Watercolor pencils are great for working on the spot—very portable, non-messy and no worries about getting sand in your palette! Just draw the basic subject and wet carefully with clear water, on the spot or later when it's more convenient. I love the subtlety of a limited palette and a variety of shapes. Here I used Cobalt Blue, Ultramarine Blue, Yellow Ochre and Burnt Sienna.

Tidepool Watercolor pencil on hot-pressed paper $3" \times 4" (8cm \times 10cm)$

Cliff House

Sometimes a painting grows out of sketches and photos—we may wait days, months, even years to recreate the magic. Here, I'd been fortunate enough and had time to do a fairly detailed sketch then took a resource photo or two before having to leave.

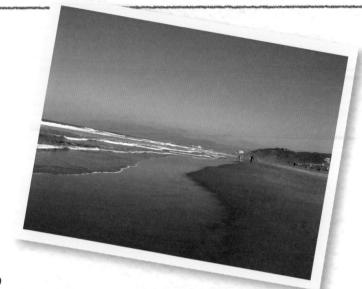

MATERIALS

SURFACE

Strathmore cold-pressed paper

PIGMENTS

Burnt Sienna, Cobalt Blue, Phthalo Blue, Raw Sienna, Ultramarine Blue, Yellow Ochre

BRUSHES

1-inch (25mm) and ½-inch (13mm) flat nos. 6 and 8 round stencil brush

OTHER MATERIALS

HB pencil, fine-point pen, masking fluid

Reference Photo

When I finished, I snapped a quick photo for later reference. It is from a slightly different angle, but it has most of the basic information. (As you can see, photos seldom offer as much specific or focused detail as you can capture in a sketch.)

I loved the beach near San Francisco and have done several paintings from my sketches, studies and photo references. My sketch of Cliff House is one of my favorites, so I decided to paint it (with the help of the photo I'd snapped that day).

Sketch Quickly

Sketching on the spot allows you to capture the scene in very simple, clean, graphic ways. Concentrate on what interests you most, and then, if there is time, continue to work.

Quick, tight squiggles suggest the rough trees on the hill overlooking Cliff House. I used dancing motions with my pen point to capture the effect of the incoming waves. I had more time to work than I expected, so I was able to add more to the foreground area.

This sketch was done with a fine-point pen. To simplify the scene further, I edited out most of my fellow beach bums.

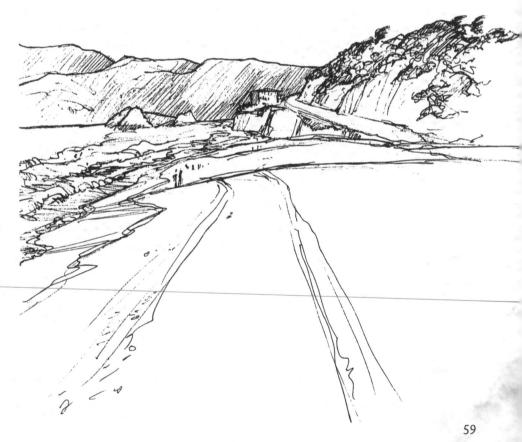

From Sketch to Painting

Plan your composition based closely on your sketch and lay in the main shapes with an HB pencil. Use masking fluid to protect the whites of the waves and buildings, but be sure to wet your brush before dipping it into the masking fluid and wash it immediately afterward, or the masking fluid can ruin it.

When the masking fluid is thoroughly dry, add your first washes. Here, the colors are mostly Cobalt Blue, Burnt Sienna, Raw Sienna and a touch of Phthalo Blue. Keep the latter very diluted or it will take over. It is a strong staining color.

To provide further definition, add a bit of Yellow Ochre to the far hills while the blue is still wet.

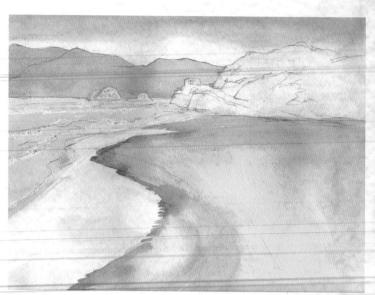

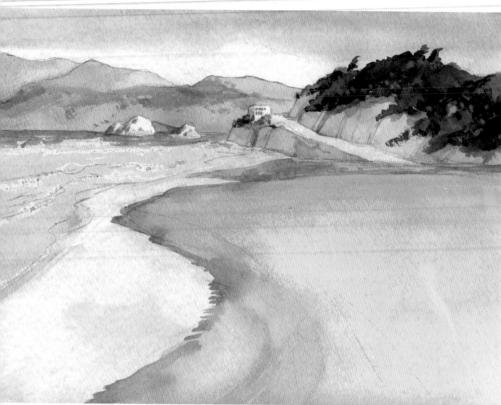

Lay in Secondary Washes, Deepen Colors and Add TreesLay in secondary washes in the buildings and rocks out in the bay, using a midtone of Ultramarine Blue and Burnt Sienna. The cliffs are warmer, with more Burnt Sienna and Yellow Ochre in the mix. For the road, leave the white paper exposed.

The distant ocean gets a darker wash of Phthalo Blue. Use a hint of green (made with Phthalo Blue and Burnt Sienna) to suggest the trees in the far hills.

Variegated Wash in Action

A strong mix of Phthalo Blue, Cobalt Blue, Burnt Sienna and Raw Sienna form the basis for the near trees, above Cliff House. This is a variegated wash done with a ½-inch (13mm) flat, with colors allowed to mix on the paper as well as the palette. Just as the wash begins to lose its shine, drop in clear water with a small, round brush to make lighter-colored treetops.

Remove Liquid Mask and Add Final Details Remove the liquid mask and develop the wave with stronger mixes of Phthalo Blue and Cobalt Blue. Add some spatter to the beach to suggest sand. Add definition with shadows and a bit of detail.

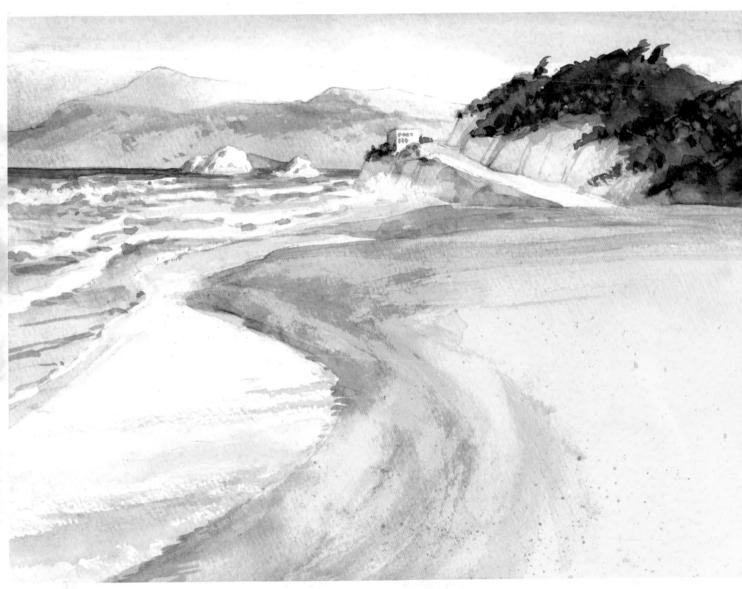

Cliff House
Watercolor on Strathmore cold-pressed paper
9" × 12" (23cm × 30cm)

Lift Pigments to Create Misty Clouds

You can get the effect of clouds obscuring the distant hills by lifting the pigment with a bristle or stencil brush and clear water. Blot away the excess. Here, a somewhat stronger wash of green

(made from Phthalo Blue and Burnt Sienna) makes it clear how drybrushing can suggest the distant tree-covered hills.

Natural History Sketches—Plants and Wildlife

Zero in on the details that define a particular habitat. Field sketches, nature journals, botanical paintings and even wildlife art focus more on the particular than the general. The larger landscape or seascape may or may not play a part in the finished work, in these cases.

Your field sketches can be little more than quick gesture sketches. Lay in a bit of color or not, as you choose. You may prefer to settle in and do a complete painting of the plants or flowers in the vicinity on a white background. You'll develop a unique relationship with each place.

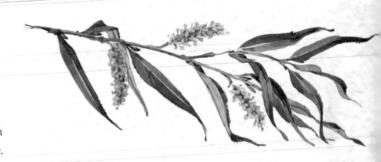

Take Your Time

Perhaps you've never noticed the flowers on a weeping willow. When you slow down and pay attention, you discover all kinds of small, perfect details.

Touch-Me-Not!

Jewelweed pods are fun. When they are fully ripe, they literally explode when you touch them, throwing their seeds in all directions to assure the widest possible distribution. No wonder this plant's other common name is touch-me-not. A quick, simple sketch like this one, in ink and watercolor, helps capture the sense of motion.

Explore

In moist areas, you often see a variety of wildflowers and plants you don't normally find elsewhere. There may be rich strands of horsetail or equisetum or a bank of colorful jewelweed (illustrated above). Take the time to paint and explore the unique properties of these plants.

Be Flexible

Don't let a great subject get away because you don't have "the proper tools." You can always refine your sketches later. Or, with the help of field guides or photos, you can develop them into more finished works with correct markings and details.

This frog was a lightning-quick sketch in black, wax-based colored pencil, with watercolor washes added later. The turtle at top is a simple ink sketch, and the snapping turtle in the middle is a very quick pencil sketch.

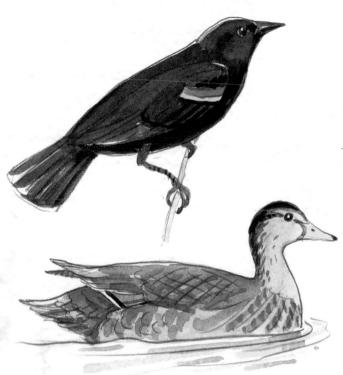

On the Move

Birds tend to move frequently, so a pencil sketch may be all you have time for. Remember their markings and add them later, or look them up in a book. Don't feel as though you have to do an illustration worthy of a field guide—you don't have to paint every feather. Getting their essence down with energy and life is at least as important, if not more so.

I used colored pencils on this red-winged blackbird as well as on the duck. I added watercolor later to suggest their markings.

Flat Fish

A simple rule of thumb when sketching or painting fish is that they are usually rather flat. That is, they are longer and deeper than they are thick (think of a ribbon shape and flesh it out a bit). The backbone that runs close to the top of the fish defines the motion.

Painting a Waterfall

Waterfalls are usually almost entirely white water. There are any number of ways to paint them, from almost photographic in detail to as simplified as possible. The final painting in this chapter is a waterfall demonstration that is somewhere between the two extremes of detail.

Simple Washes and Strokes

In this strongly graphic handling, the shadow shapes are only hinted at, with pale washes of blue. Washes that are darker in value give the impression of the more deeply shadowed areas, while the foam at the waterfall's base. is painted with quick, loose strokes that mimic the motion of the water itself. When everything is completely dry, you can scratch through a few sparkly lines with a sharp blade.

Minimal Detail

From a distance, very little detail is visible. The water fall may look like little more than a silver ribbon against a cliff face. You can use a bit of drybrushing and scratching to good effect, but little else is needed.

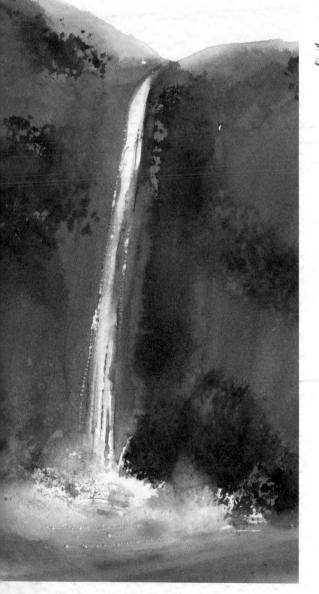

Different Strokes Try a variety of stokes to capture the effect

of moving water. Here you see (from top) a flat brush used in both a dry-brush and straight manner, a rigger brush used to make linear strokes, a round brush to suggest intermittent or complex "braided" streams, a ragged old moth-eaten brush and a round brush applied lightly on the side of the brush's body to depict the frothy area at the bottom of the

falls. At left, a bamboo pen was used to apply masking fluid, not all of which has been removed.

Promised Land

When I found this beautiful little waterfall deep in the Pennsylvania Poconos, I couldn't resist painting on the spot. I had gone out expecting to paint something entirely different, but the sound of falling water downstream drew me, and I had to give it a try. Time was all too short, so first I did a thumbnail then a larger value sketch so that I'd have a framework if I ran out of time—which I did!

MATERIALS

SURFACE

Fabriano cold-pressed watercolor block

PIGMENTS

Burnt Sienna, Cadmium Yellow Medium (optional), Payne's Gray, Phthalo Blue, Transparent Yellow, Ultramarine Blue

BRUSHES

½-inch (13mm), 1-inch (25mm) flat no. 6 round

OTHER MATERIALS

brush-tipped pens in shades of gray natural sponge

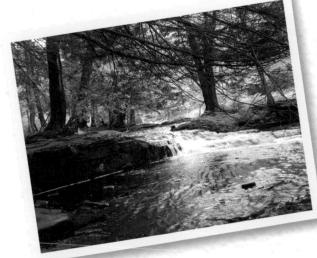

Reference Photo

The spot was idyllic and primal. The waterfall sparkled and roared, the rocks were acid-green with moss, and I felt as if I were miles and millennia away from civilization. It was the perfect place to paint!

Thumbnail Sketch

When considering a complex subject like this—especially one where I know I won't have time to finish—I find preplanning sketches like this thumbnail are a big help.

Value Sketch

A quick pencil sketch let me get the bones of the scene down on paper. Then I added a range of values using brush-tipped pens in shades of gray.

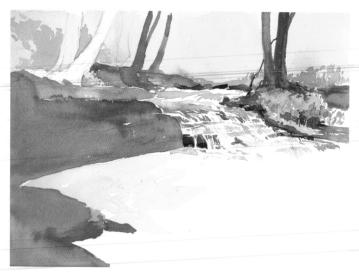

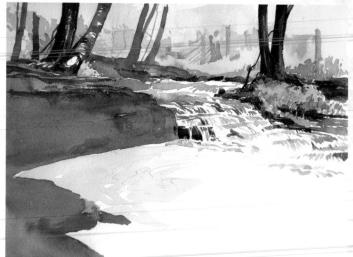

Lay in Washes

Working as quickly as I could, I transferred my sketch to my Fabriano watercolor block by eye and laid in the first washes, keeping values light in the background and painting around white areas. I used a 1-inch (25mm) flat for these largest areas.

I mostly used Transparent Yellow, Phthalo Blue and Burnt Sienna. You can mix a wonderful range of greens with just these three colors (substitute Cadmium Yellow Medium if you prefer).

The waterfall itself was a riot of color. The pure white of the falling water, shaded areas that varied from pale to a medium gray-blue, earth tones where the color of the rock showed through and wonderful reflections from the sky and trees. I pushed the color, emphasizing these differences, because I wanted this area to really sparkle. At that point I ran out of time and had to settle for taking an array of resource photos. The one on page 65 is the closest to what originally inspired me, though it was taken from a slightly different angle.

Add Midtones

Later, back at home when I could get my photos developed, I continued painting. Here, I've added the midtones in the greens and more distant trees, just suggesting the shapes of trunks and branches in the shadow areas of the background. I used a ½-inch (13mm) flat for the broader areas and a no. 6 round for the trees and branches.

You need to use a stronger value and more detail on the trees on the left to give them their proper importance. I paid more attention to the bark patterns on the big leaning birch, letting my brush follow the rounded shape, and included more details.

The rocks are mostly Burnt Sienna and Phthalo Blue, with a little stronger mix of Transparent Yellow to suggest the moss that grew abundantly in this moist environment.

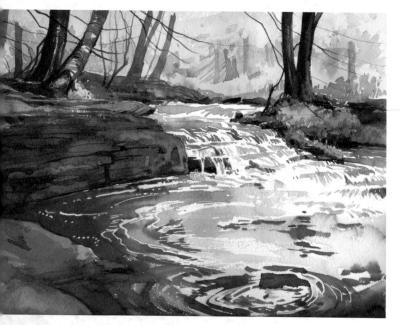

THIGHLIGHT AND Accent

After masking some of the highlights in the water with masking fluid, I laid in stronger washes below the falls and in the shadowed areas where the water was less active. This is basically a mix of the same pigments, leaning more toward the Phthalo Blue. When those first layers were dry, I carefully removed the mask and softened some of the edges with clear water.

I've begun to add small, dark accents in the rocks and some of the branches, using a small round brush and a mixture of Burnt Sienna and Ultramarine Blue, with a little Payne's Gray in the darkest areas.

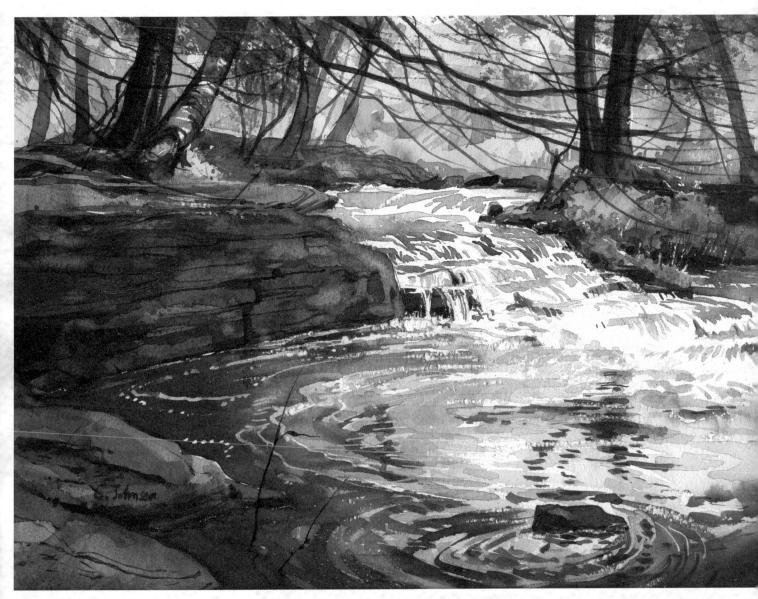

Hidden Falls, Poconos Watercolor on Fabriano cold-pressed watercolor paper 9" × 12" (23cm × 30cm)

Check Shadows and Reflections

I referred to my photo resource to check shadows and reflections in the water and added them where needed. Using the deepest value I could mix, I applied the rest of the branches with the end of a sharpened stick. I painted the darker foliage at top with a natural sponge dipped into a deep green mixture comprised of Phthalo Blue and Burnt Sienna. I used a light touch so the rough, varied texture of the sponge would act as my painting tool.

CHAPTER SIX

Prairies, Meadows and Fields

he prairie is full of life. Hundreds of plant varieties, insects, reptiles, birds and mammals, large and small, offer painting subjects for a lifetime of study. The ever-changing sky, arching from horizon to horizon, and the shifting colors of the land delight the painter's eye.

Tallgrass prairie is an ecosystem unto itself. The mixed grasses can be quite tall and blow in the wind like waves on the ocean. At one time, eastern settlers thought of this vast, open landscape as the great American desert. It is anything but. It is lush and varied and endlessly fascinating.

If you think the classical tallgrass prairie is the only type of prairie there is, think again. In fact, there are four distinct types of grasslands in the United States alone: tallgrass, midgrass and short-grass prairies and the California grasslands. A smaller, similar natural grassland can be found in Washington state. The grasslands extend up into much of Canada and mirror grasslands in other countries, from the South American pampas to the steppes of the Ukraine, Russia and Mongolia to the African veld.

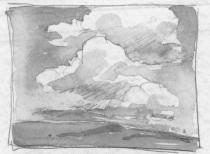

Decide on Format and Focus

Choose your format as well as your focus. You may prefer to direct attention toward that big sky (top sketch), the sea of grass to catch that sense of space and rhythm (middle) or go for the wide-angle effect (bottom). Try out a variety of color schemes and moods, but keep it simple for now. These quick thumbnail sketches were done with a dark gray colored pencil and watercolor washes. The rectangular sketches are no bigger than 2½" × 3½" (6cm × 9cm), a generous size for thumbnail sketches.

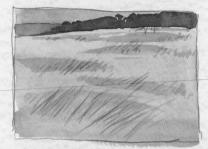

Study the Grasses

Try zeroing in on the grasses, either as quick sketches of the silhouettes against the sky or as a more focused and detailed painting. Here, a crisp pencil drawing gives a framework for quick watercolor washes.

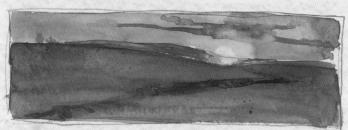

Trees That Follow the Watershed

In these wide-open spaces, you may notice a line of trees snaking off in the distance. Often, these trees mark a river or stream or even a seasonal watershed that's dry much of the year. Trees sink their roots deep in these low places, seeking moisture where they can. Including them in your landscapes makes for an interesting design element and breaks up an expanse that might otherwise lack definition.

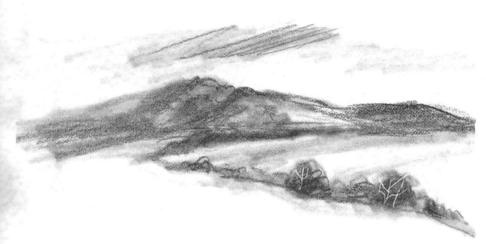

Sycamore Study in Black and White

I used a soft graphite pencil for this simple landscape, using a rolled-paper "stump" to smudge it for subtle values. To suggest the sycamore trees in the gully, I impressed the blunt tip of a nail file into the paper and then ran the pencil point lightly over the paper, leaving the trunks and limbs lighter in value.

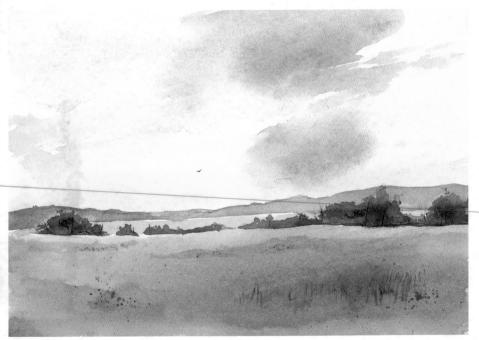

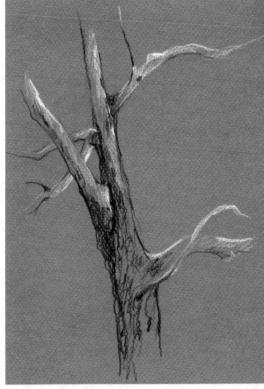

Sycamore Sketch

Sycamores are beautiful trees. They have tight, scaly brownish bark below, but they shed that bark on the upper limbs to expose pale, smooth, greenish white. It's fun to sketch them with black and white colored pencils on a toned ground, either in preparation for a more finished painting or as a finished drawing.

Simple Palette

In this little watercolor, painted on the spot on a lovely rainy day, you can see the line of trees that mark the watershed, bisecting the distant field. I used only primary colors for this one—a warm and a cool red, blue and yellow. As you saw in chapter three, you can make almost any color you wish with this simple palette.

Primary Prairie Watercolor on Fabriano cold-pressed paper 9" × 12" (23cm × 30cm)

Wildflowers

Prairies, meadows and the edges of fields are often full of wildflowers, changing their bright dresses from season to season. You may find yellow wild mustard in the spring; a variety of golden sunflowers, sky-blue chicory, reddish orange Indian paintbrush and creamy-white Queen Anne's lace in midsummer; perhaps clary sage and coneflowers later in the year. Take time to wander a bit, and make field sketches of the flowers you find, as well as any notes that you might find helpful.

Try to discover wildflowers that are characteristic of your location—typically prairie or old-field flowers. Some flowers produce fruit later in the season. Follow the progression from the first blooms to the rich, ripe fruit to get a feel for the place.

Leave Room to Grow

Reserve a page in your sketchbook to allow space to record changes as the plant matures. Leave room for berries or leaves or any other details you may want to add as the season progresses.

Notice the shape of the flower or, in the case of the elderberry blossoms shown here, of the whole flower head, called an umbel. Use a pencil guideline to capture the overall shape, as I did with the loose oval line you see here. Later, when the plant matures, add the fruit.

White-on-White

Painting a white flower against a white background can be tricky—you'll probably want to suggest some background color or push the color a bit to make it pop.

Vary the rich dark hues in the berries for interest and authenticity, and be sure to leave some untouched white paper to suggest the shine.

Reference photos can be a great help when you don't have time to really stop and paint, particularly if you have a macro lens or macro setting on your camera. It would be difficult to paint all the details you see here (the hairy backs of the chicory petals weren't even visible with the naked eye), but the photo captures shape and color very well.

Pay Attention to Shape and Perspective

Notice the apparent shape of the flower head in relation to your eye. It follows the rules of perspective on a small scale. Notice, too, that the pistils and stamens make a kind of open cone shape in the center.

Use Reference Photos

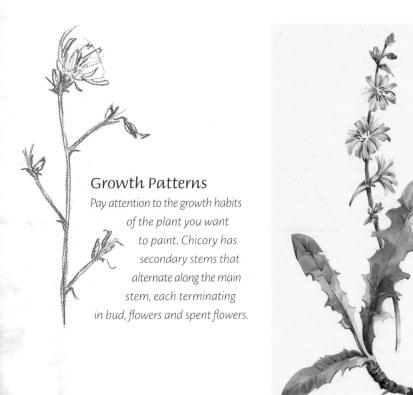

The Full Picture

An interesting approach from the botanical standpoint is to include the whole plant, from root to flower. Chicory is common enough that this isn't a problem, but be sure you're not uprooting an endangered plant species! A mixture of Cobalt Blue with the barest touch of Phthalo Blue seems to capture that amazing azure.

If the plant is too tall to include on the page, you can always paint two separate parts, as I did here. The slightly creamy color of the paper gives a pleasing antique look.

When you're ready to do your finished piece, pay attention to the shape and position of the petals and how they overlap or curl. This will make a much more realistic flower than one that looks too uniform. A few tiny lines will suggest the hairy stems.

Colors used here were Burnt Sienna, Cadmium Red Medium, Cadmium Yellow Medium and Phthalo Blue. A springy no. 7 round lets you paint a leaf or petal almost with a single stroke, and backruns suggest volume.

More on Shape and Perspective

You can use geometric shapes to help you correctly draw the shape of your flower. These sunflowers will fit, roughly, in circles and cones, as many wildflowers will. Pay attention to perspective, even on this small scale (as with the chicory, above). You'll notice that the center of the flower appears higher on the circle. The bud fits roughly in a cone or cup shape, with the dark brown center nestled in the middle.

Cultivated Fields

Cultivated fields change their dress from year to year as the farmer rotates his crops—short, round-leafed soybeans one year, tall corn another and occasionally a hay crop. Form a relationship with a specific place, and revisit it in a variety of seasons.

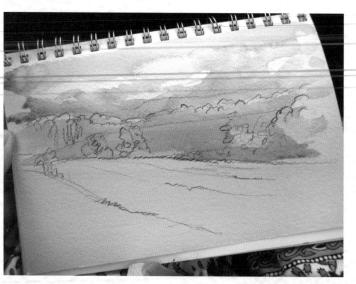

Visitors and Inhabitants

Shy white-tailed deer may feed near the edges of a cultivated field, always aware of nearby cover. Meadowlarks and bluebirds may perch on the fence and nest nearby. Quail are common here, too, and in some areas, you'll see ptarmigan or long-tailed pheasant. In the fall, after the harvest, birds of many types can be found in the grassy areas, feeding on stray seeds or grains. Look for crows, grouse or wild turkey. Overhead, hawks wheel and turn, looking for dinner.

This is the area as it looked in early September, rich with soybeans.

Rainy Day Adjustments

On drizzly days like this, working in the car is a great option, and working small makes everything much easier. This is a Strathmore watercolor sampler pad that comes in a variety of paper surfaces, thicknesses and colors. I was working on a soft gray paper to match the damp gray day.

When I'm working quickly, I like to sketch in the basic forms with a dark gray colored pencil, then lay in washes in a quick, free manner. The light underwashes can extend to cover the places where darker areas will be, as in the distant tree-line.

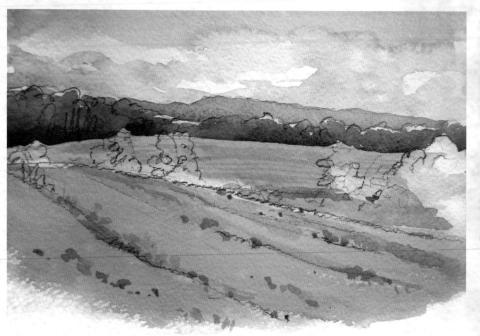

Patterns of Green

The rows themselves make interesting patterns, delineating the lay of the land and providing a sweeping perspective. You can suggest this with just a few lines.

When the first washes are dry (be patient on humid or rainy days), add the next layer, darker and more emphatic than the initial washes. Burnt Sienna and Phthalo Blue, painted wet-in-wet, make lovely varied greens.

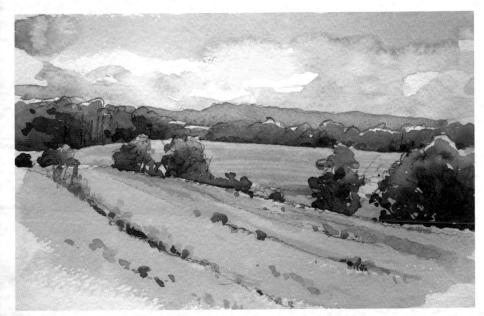

Add Details Later

Wait till the secondary washes are dry, and go back in with additional details: the trees that follow the gully, shadows under distant trees, more detail in the rows. (The color is slightly different here because the first two photos were taken in natural light on that gray rainy day.)

Rainy Day in Mosby Watercolor on gray toned paper $5" \times 7"$ (13cm \times 18cm)

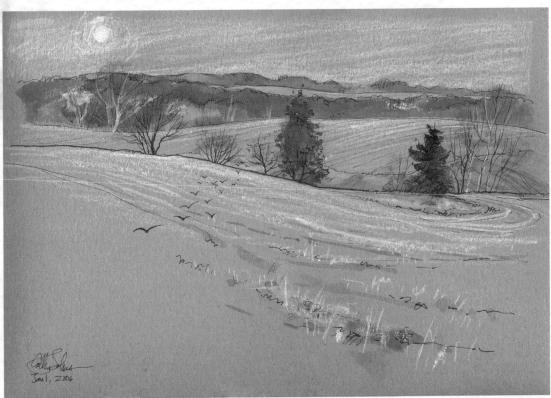

Seasonal Changes

This is the same field, on a winter's day with the stubble of last year's corn crop.

January 1 Ink, colored pencil and gouache on toned paper $9" \times 12" (23cm \times 30cm)$

Fiery Renewal

Part of the natural life cycle of the prairie is the burn. It allows new seeds to mature and germinate and clears off the huge fuel load that can choke the ecosystem. Sometimes nature sets these fires (with lightning). Sometimes humans set the fires in a controlled burn.

Even during a controlled burn, I suggest using a quick sketching technique. You can add color later, as I did with this journal drawing of the burning prairie at the Martha Lafite Thompson Nature Sanctuary in Liberty, Missouri. I worked rapidly with a pen, then added the colored pencil a little later when the fire had passed but the scent of smoke was still in my hair and on my clothes. I used colored pencils here, but I could do a credible watercolor with this much information.

Birds of the Grasslands

These open areas with weedy edges are great habitats for birds, particularly if there are the remains of a crop to be gleaned. You're likely to see anything from wild turkeys, hawks and owls to quail, grouse, prairie chickens and pheasant, perhaps even a huge sandhill crane. There also are a variety of small songbirds like sparrows, meadowlarks, bluebirds and more. There's no lack of great avian painting subjects.

Move Fast!

Birds are usually rather wary of people, so you'll want to be prepared to sketch quickly. Have your tools at hand. Use gesture sketches, or block in shapes with a few quick lines. Then develop your impressions further from memory, resource photos or even a published field guide if you need help with the patterns of the feathers.

Fit the shapes into roughly geometrical forms if it helps you. Then you can continue to refine and develop the shape and details at your leisure.

Sketch With Watercolor Pencils

Watercolor pencils are great for quick sketches.

Pick up the pencil that most closely approximates the colors you see and scribble in areas of color.

Touch them with a damp brush to blend. You can layer colors while the pencil is still dry or add color to a damp wash. Or try letting your sketch dry thoroughly and then add another layer and wet to blend.

In this little sketch of a male prairie chicken in mating display, I made use of Faber-Castell's Albrecht Dürer watercolor pencils in Burnt Ochre, Dark Chrome Yellow, Pale Geranium Lake, Sanguine, Ultramarine Blue and Van Dyck Brown, with just a touch of black for the eyes and the darkest areas of his plumage.

The startling bright orange-gold color is intended to capture milady's attention, and her favor.

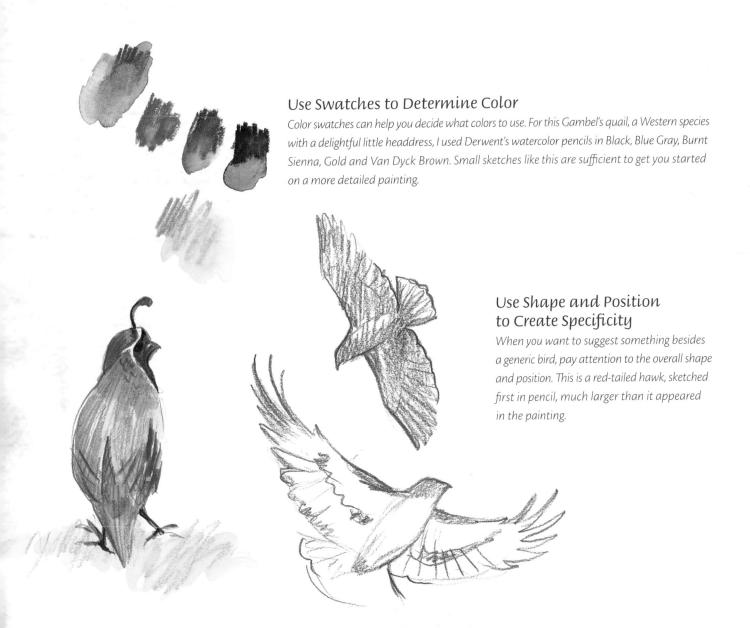

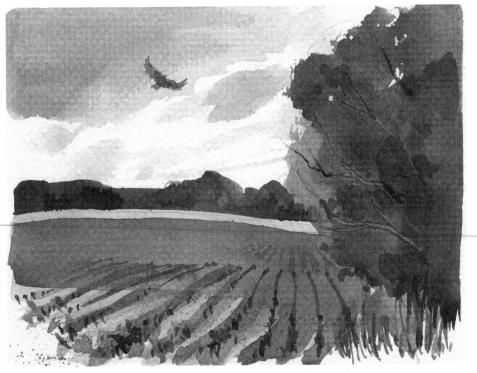

Birds as Components of a Scene

You may prefer to just include a bird as part of the larger picture to give a sense of life. In this plein air painting, a hunting hawk soars high over nearly ripe soybean fields, hoping to spot a meal.

The Hunter Watercolor on Cachet cold-pressed sketch journal paper $5" \times 7"$ (13cm \times 18cm)

Limestone Fence Posts and Windmills

Rural artifacts connect us to our history in ways big and small. Windmills are fairly common in many rural areas. Limestone fence posts are more often seen where suitable trees don't grow in usable numbers. (These days, though, unlovely steel posts are the norm!)

Fence Posts

In some areas, wood is in very short supply. That's why early settlers in the Great Plains sometimes built sod houses until they could import the lumber to build more permanent homes. Even the fence posts may be limestone. You can see the grooves in these massive posts for holding the wire in place.

Variations on a Theme

This post was just down the line from the one in the photograph; they're marvelously varied in shape. It was done with layers of watercolor pencil, applied dry, wet carefully and allowed to dry again. It needed a bit more punch, so I added another layer and wet it again, then added a little dry pencil work for texture. The tall weeds are Queen Anne's lace, a very common sight along the edges of old fields.

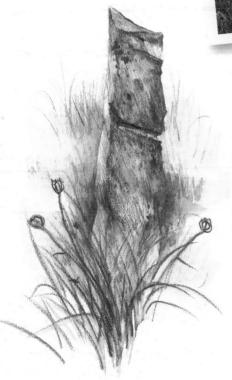

Windmills

In some rural areas, you may see windmills still in use to generate electricity or pump water. The newer windmills are not as picturesque, but many of the old mills are still standing.

Pay attention to what you see: the shapes of the blades, the number of them, the angle from where you sit. It's not necessary to be an engineer or an architect to depict these in an interesting way, but a degree of accuracy lends believability. This quick annotated sketch is in my journal. It was actually a cloudy, gray day, but it's okay to tweak color and mood if you want.

Mammals of the Grasslands

Most mammals are shy of humans. If you get the chance to sketch a groundhog, prairie dog, rabbit or deer "up close and personal," take advantage of it. Be ready, use whatever's at hand, even if it's not the art supplies you would have preferred, and draw as quickly as possible.

Putting grassland animals into a landscape is more challenging than sketching them by themselves. You may choose to depict them in the distance or as the main subject of your painting, as I did in the bison drawings on page 78. I had the wonderful opportunity to get close enough to an American bison to touch its nose (from the other side of a very stout fence, of course!).

Do What Time Allows

I pulled into the parking lot at Watkins Mill, near the restored nineteenth-century church and the big field nearby, and there, not ten feet from my Jeep, was a cottontail rabbit. I didn't want to lose the moment or startle the little creature with too much scrabbling about through my field kit looking for the "perfect" art supplies. I had only an indigo colored pencil and a few sheets of tinted watercolor paper in a 5" × 7" (13cm × 18cm) pad, so that's what I used.

I had no idea how long the rabbit would stay put, so I did a very quick gesture sketch, then a sketch with simplified shapes for the body parts. I was quiet and nonthreatening, so after the first anxious awareness, the rabbit seemed to accept my presence. It took a quick look at me, then went back to what it was doing. I even had long enough to do a simple wash sketch, capturing the coloring.

Later, using other sketches and resources, I added an ink drawing of a younger rabbit to the page. The point of creating various resources such as these is to provide us with enough information to do a more complete work, such as the little watercolor of the bunny shown at right.

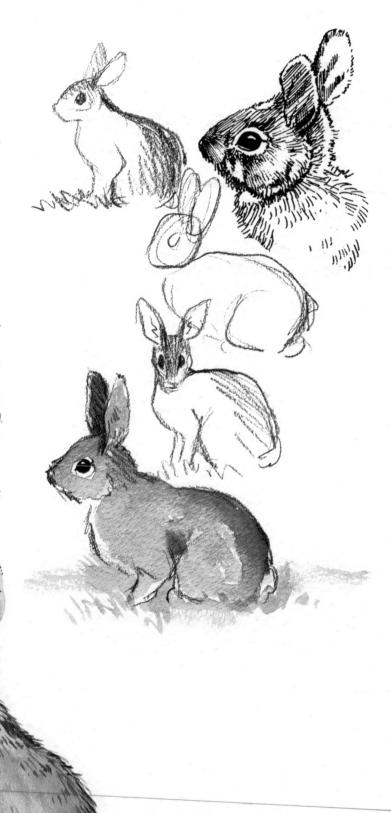

Groundhogs

Whether you're on the prairie or at the edge of a farm field, you're likely to see groundhogs or their relatives, the prairie dogs. They have very similar body shapes, and both stand firmly planted on their hind feet and fat little bottoms to survey their domain. If you live in close proximity to them, you may see them lounging, grooming or teaching their young. Draw them quickly.

This groundhog or "whistle pig" was at the edge of my yard, looking all around for any sign of danger. A day or two later, when he was sure I meant him no harm, I found him snoozing in my old metal garden chair on the back deck!

I've drawn groundhogs many times before, so practice had allowed me to capture his pose quickly in ink. Later, I added fresh, quick watercolor washes.

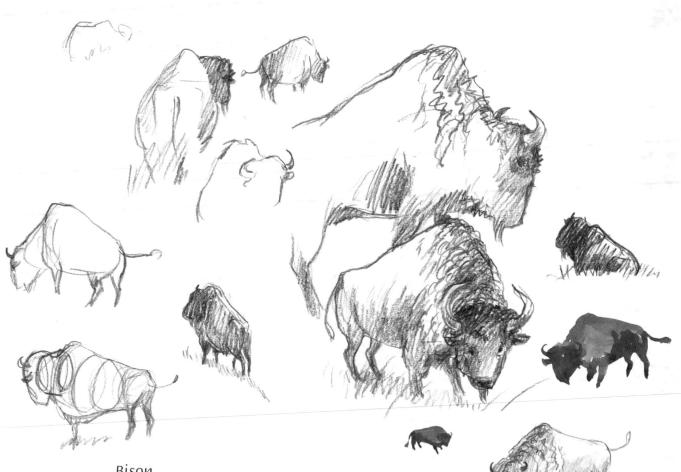

Bison

Draw as many sketches as you have time for, from as many angles as you can manage. If it's safe to do so, approach your subject to get more details. If you can't, use binoculars. Use gesture sketches, block in the forms and suggest form and value. You may even want to do some quick color sketches.

Bison

These animals are not tame pets; they can be quite dangerous, so work at a distance or with a strong fence between you. They once covered the prairies in the thousands. If you're fortunate, you may get to see them on some patch of prairie that's managed to escape the plow.

MATERIALS

SURFACE

Strathmore cold-pressed watercolor block

PIGMENTS

Burnt Sienna, Cadmium Red Medium, Cobalt Blue, Payne's Gray, Ultramarine Blue, Yellow Ochre

BRUSHES

1-inch (25mm) flat nos. 3, 5 and 7 round small bristle brush

OTHER SUPPLIES

mechanical pencil

If you have the chance, take plenty of reference photos. This close-up was very helpful when I translated my sketches to the watercolor paper.

Experiment With Palettes and Brushes

A limited palette can be very effective when painting wildlife. Here, I made swatches of Burnt Sienna, Cadmium Red Medium, Payne's Grav, Ultramarine Blue and Yellow Ochre to help me plan where I wanted to go. Burnt Sienna and Ultramarine Blue make a lovely variety of neutral grays, and Yellow Ochre and Payne's Gray (or black) make a rich, subtle olive green. Play around with your brushes to see which might work best to suggest the various textures.

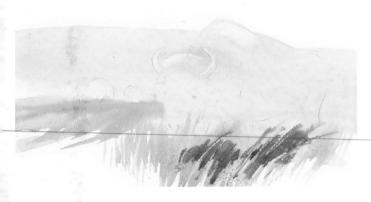

Apply Underpainting

I knew that Yellow Ochre used as an underpainting would give my big mammals a warm glow, so I just painted right over where I had sketched them in, using mostly Yellow Ochre with a little Burnt Sienna and Cobalt Blue and a 1-inch (25mm) flat. I lifted a bit of the wet color with a clean, damp brush where the light would strike the big cow in the foreground, in case I wanted to go with a lighter value there.

I allowed a little wet-in-wet work with Burnt Sienna and Ultramarine Blue dry till it was just damp. Then I scraped through it with the end of an aquarelle brush to push the pigment out of the way, suggesting the rough grasses around and under the closer animal.

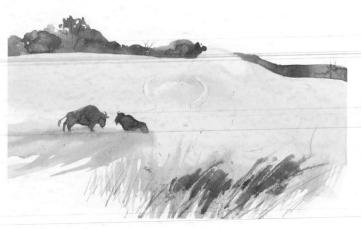

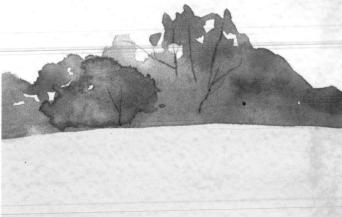

Begin to Suggest Foliage, Trees and Hills Yellow Ochre and Payne's Gray made the soft, subtle green of the distant trees, painted with a no. 7 round. I let the tip dance playfully to suggest loose foliage. Burnt Sienna dropped here and there into the still-wet wash formed hard edges that look as though a few of the distant trees are beginning to change color.

A bit of Ultramarine Blue mixed with Yellow Ochre suggested the blue hills in the distance. I painted the hills while the trees were still wet so the two areas would blend. Then, I painted in the distant bison, relying heavily on my on-the-spot sketches.

Detail

This detail shot shows the lacy edges of the distant tree line. Het the tip of my brush dance to suggest foliage at the top. A little wet-in-wet touch made hard edges that read as individual trees. I drew back into the damp wash with my mechanical pencil to suggest distant tree trunks.

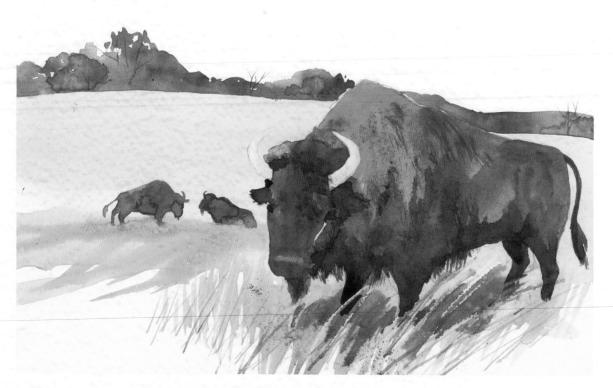

Paint Foreground Bison

Next, I painted in the closer animal, mostly wet-in-wet. I pushed the color a bit by adding Cadmium Red Medium to the rough hair of her hump. Otherwise, I mostly used the combination of Ultramarine Blue and Burnt Sienna that I rely on heavily when painting browns and grays. I painted around the horn rather than masking it out. In small, relatively simple areas, this is not difficult to do, if you are patient. While this first strong, intense wash was still wet, I pulled out the paint with my fingertip to suggest the long hairs on the chin and chest.

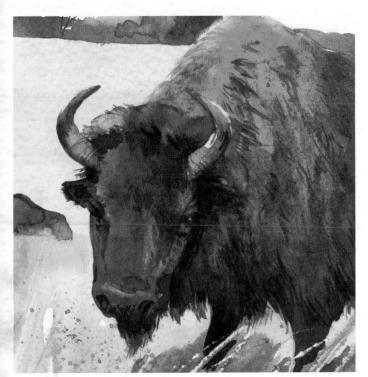

Refine Hair and Horns
I used a small, ragged bristle brush to begin modeling the rough hair of the bison's hump. A no. 3 round was great for painting the horns. The close-up photo reference was invaluable for capturing the subtleties of shape and texture.

Final Touches I toned down the color in the hair by continuing to add texture with a small brush. I then modeled the face and eyes a bit more until I was happy with the final effect.

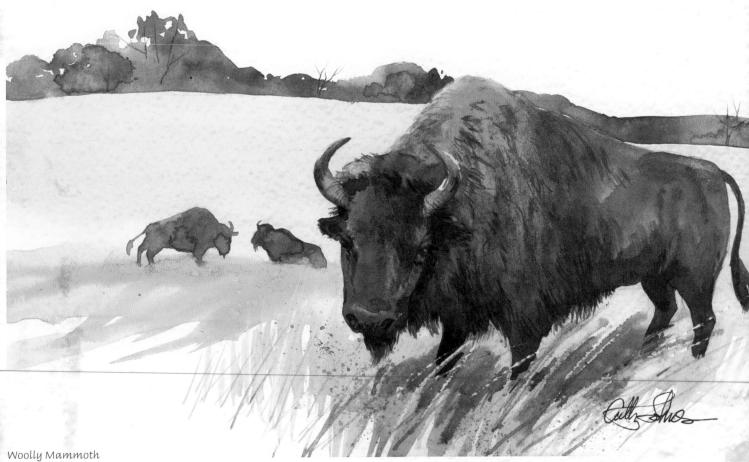

Woolly Mammoth Watercolor on Strathmore cold-pressed paper $9" \times 12" (23cm \times 30cm)$

CHAPTER SEVEN

Mountains

ns The

Someone I knew once said, "If you've seen one mountain, you've seen 'em all." Nothing could be farther from the truth. I've traveled from the Ozarks of my home state to the Appalachians and Great Smokies to the Adirondacks, from the Rockies to Nevada's Black Mountains to the San Gabriels in California. The variety is staggering and beautiful.

Ancient mountain ranges like the Ozarks and Great Smokies are often rounded and worn down, covered with enough soil to support an amazing variety of flora and fauna, including some very large trees. Newer ranges are rugged and raw, virtually bare outcroppings, supporting a few plants at lower elevations. Or, like the Rockies, they are treeless and snow-capped above the tree line and clothed with evergreens and aspens below.

They are definitely not all the same. They are a delight to the eye and a wonderful challenge to paint.

Don't Oversimplify

Kids tend to think of mountains as a simple series of saw-toothed lines, zigzagging across the page. Resist the urge to create these stereotypical forms and your work will instantly become more interesting.

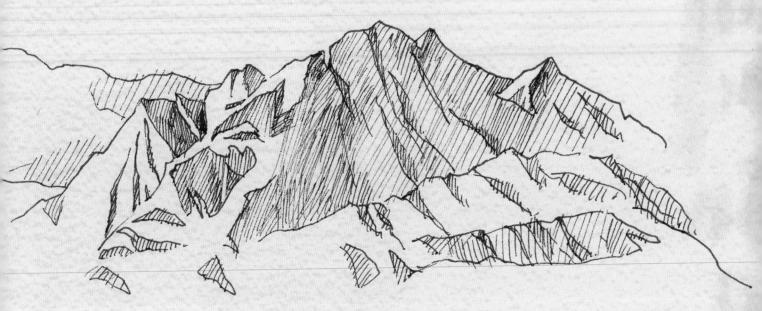

Map the Mountains

Take your time and "map" the shapes you see, drawing the major forms and looking for how they relate to one another, how they fit together. Use an ink or pencil line, and fill in the shaded areas with tone or hatched lines. Keep it relatively simple. You'll soon see just how complex and interesting and nongeneric these shapes are.

By the way, this is Frenchman Mountain, just outside Henderson, Nevada. As I sat looking out toward the distant mountains, I drew them in my journal, using an art pen with sepia ink.

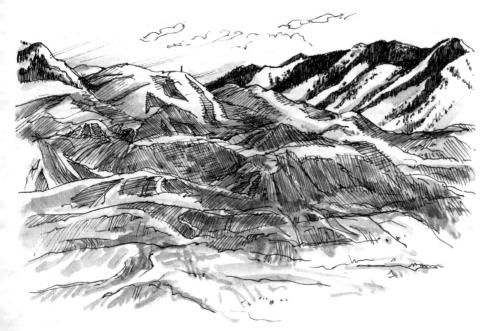

Time for Details

If you find yourself with more time, you can carry the mapping as far as you like. Here, my plane was delayed at the Salt Lake City airport, and I passed the time by drawing the view with a fine-point pen, using the mapping process described on page 82. When it became obvious we'd be delayed even longer, I got out my travel set of watercolors and painted right over the ink sketch. (Actually, this is just one panel of what turned out to be a three-page journal spread. It was a long wait.)

Use What You've Got

I hurried to complete this rough sketch before the downpour could drench us. The indigo colored pencil was near the top of my field bag, and I didn't have time to dig for a different tool.

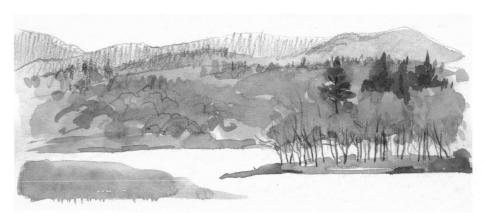

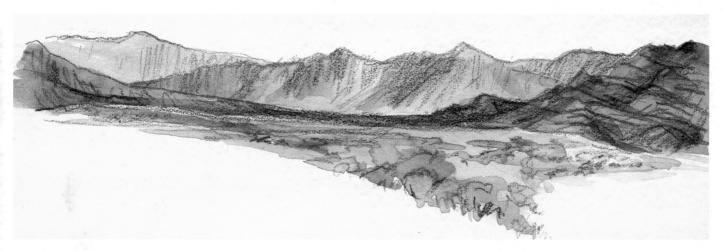

On the Road

Sometimes there's not a good place or time to stop to sketch. If you're not the driver and you're not bothered by motion sickness, you can get in a quick pencil sketch on the road and add color later.

Let your impressions of the place fix themselves in your memory, and the color will be representative of your subject.

Above the Timber Line

It makes an interesting contrast to include both the green trees and the bony, bare rocks above them, particularly if the mountains are snow-capped. Your practice in mapping the shapes will help you see accurately and place the snow fields and fingers of forest in a believable way. (Of course, it helps to have a sketch, a photo reference or the luxury of working on site.) Take every opportunity to sketch mountains. You can even sketch them out the window of a plane at 27,000 feet (8,230m), as I did here.

If you were on a level with these mountains instead of having a sky-high view, the tree line would look more uniform, but it's still not a straight line of green. Because of the tendency for soil to form more readily where it's protected, the trees will reach higher in the mountain valleys and between the ridges.

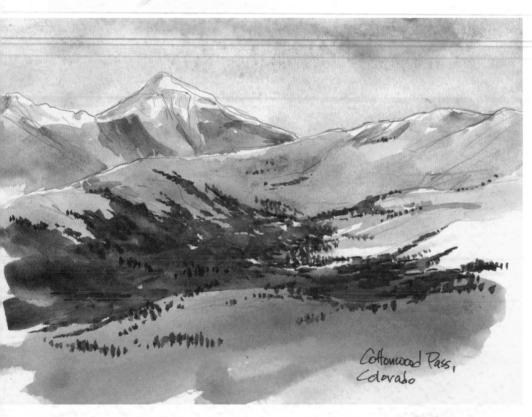

Elevated Sketching

Way above the tree line, you're liable to see snow even in the summer. The trees reach up as far as they can find soil and a foothold.

This was a simple pencil sketch with washes laid in with only two brushes, a ½-inch (13mm) flat and a no. 6 round for the details of the trees. I pounced the edge of the flat on the paper to suggest some of the trees, then painted a few individual ones at the edges and in the meadow in the foreground with the tip of a round brush.

Cottonwood Pass, Colorado Watercolor on Fabriano hot-pressed watercolor paper 5" × 7" (13cm × 18cm)

Back to Basics

Painting at home or on-the-spot can be extremely simple. I did this painting with a box of rich, granulating Kremer Pigments watercolors, a little watercolor block, a ½-inch (13mm) flat, a no. 6 round and my small water container made from a pair of travel-size spray bottles (one was cut to form a water cup).

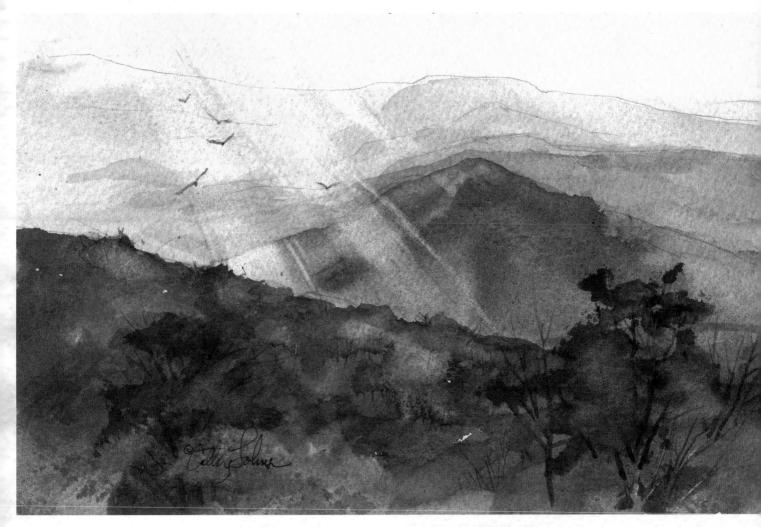

Dickey Ridge Watercolor on Strathmore rough paper 5½" × 9" (14cm × 23cm)

I shot this photo after sketching so I would have a photographic record of the place. You can see how much I edited out for the painting.

Simple Mapping

Mapping mountain ranges can be very simple when the haze shrouds them, as it so often does in the eastern mountains. Here, you see the soft blues, gray-blues and lavenders of the Shenandoah Mountains. I pushed the colors in the foreground a bit, but they were already very rich on that early November day.

Granulating colors like Ultramarine Blue and Burnt Sienna worked well to suggest the mountains in the middle distance, and a mixture of a very pale wash of Phthalo Blue and Cobalt Blue suggested those in the distance. Each receding mountain looks paler and paler, suggesting greater distance.

After everything dried, I lifted the shafts of light that pierced the haze by loosening pigment with a clean, wet bristle brush and then blotting with a tissue.

In Virginia, the vultures stay year-round, riding the warmer thermals of air. A gathering like this is a common sight, and we always greet "Buzzard" and appreciate his grace as well as his work as cleanup crew!

Trees of the Eastern and Western Mountains

As usual, the subject you choose to paint depends on where you are and what season it is. In the Ozarks in early spring, you can't help but notice the beautiful pale glow of dogwood blossoms or the hot pink of redbuds, also common in the Shenandoahs and Great Smokies.

Paint the entire tree, a stand of trees or focus on the details, field-guide style, as I have here.

Balsam Fir

This cold-loving tree is mostly found in Canada and in the eastern half of the United States. It can also be found in West Virginia and Virginia, but it is much more likely to grow in the Adirondacks than the Appalachians. Ink and watercolor work well to capture the delicately colored immature cones and short, dense needles.

Sugarbush

If you're fortunate enough to be in the mountains when the sugarbush (sugar maple) takes on fall's palette, you'll delight in painting these gorgeous details.

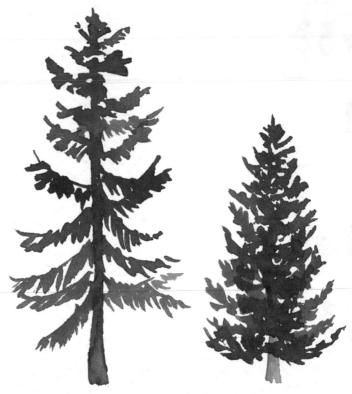

Tree Silhouettes

Pay attention to the different tree silhouettes here. A Douglas fir of the western forests (left) is very different from the dense, shorter balsam fir (right).

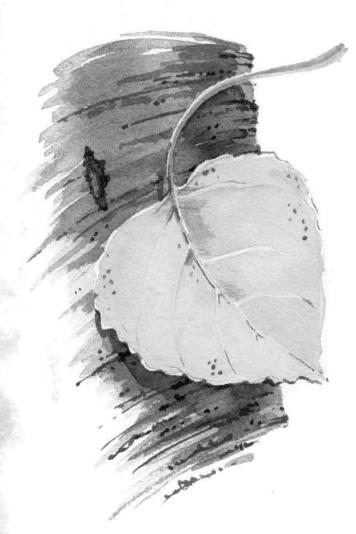

Quaking Aspen

These graceful trees have bright yellow leaves in the fall. The leaves' long stems make them wave madly in the wind, shimmering with highlights.

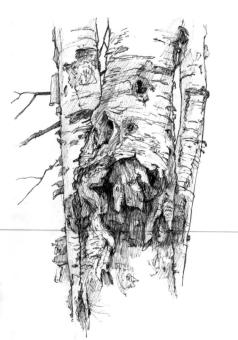

Douglas Firs

Douglas fir trees are so ubiquitous, the building industry calls this type of tree "Doug fir," as if it were a guy you'd meet for a beer! They are grown in huge tree farms for lumber and paper pulp. They also still grow wild in the Western mountains. They've got interesting fringed cones, as this detail shows.

Paper Birch

Balsam fir often grows in concert with this tree, the paper birch, as well as with aspen, white cedar, eastern hemlock and sugar maple.

Mountain Wildflowers

What flowers you are able to draw or paint depends entirely on where you are and what season it is. In Colorado's summer mountains, you're liable to see huge blue columbines. In the Adirondacks in June, you'll find bunchberry, lady's slipper orchids and more. In the Ozarks, spring brings lovely ground-hugging birdsfoot violets, with their lacy, fern-like foliage. The drier mountains of California in early fall are a tapestry of dried wildflower heads in many rich shades and colors, along with the bright coral red of California fuschia or Zauschneria. In another season, the foothills are golden with fields of California poppy.

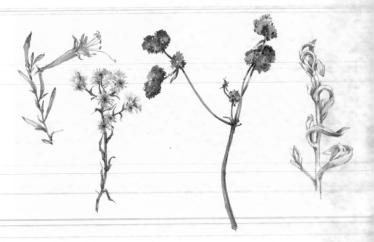

Collect Samples

Collect (if it is legal and safe to do so) a few flowers or seed heads to paint in detail. Otherwise, paint on the spot with as much detail as you can. You may enjoy trying to identify them or simply delight in their shapes and colors.

These varied flowers were thick along State Highway 39 through the Angeles National Forest at the end of September. The Angeles National Forest is in the San Gabriel Mountains.

Enliven With Watercolor

A quick pencil sketch can be brought to life with a little water-color or a wash.

Abstract Complexity

A complex subject may work well with a somewhat abstracted approach. Acrylic, gouache or other opaque medium may help, or try masking fluid to retain the lights.

Angeles Wildflowers Watercolor on Strathmore cold-pressed paper 12" × 9" (30cm × 23cm)

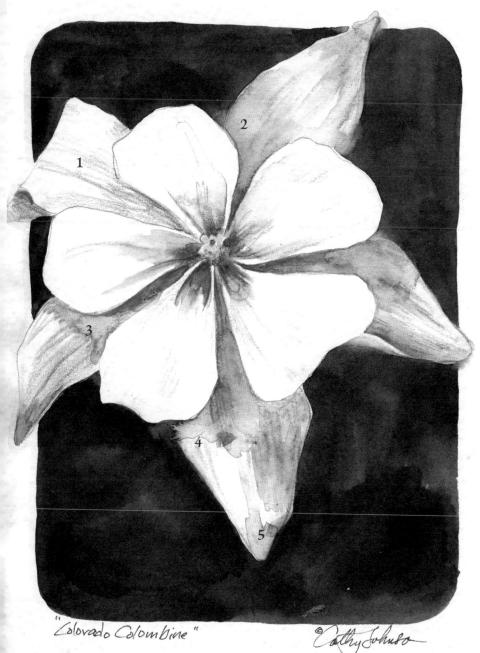

Focus on the Specific

Focus on a single flower. If you have the opportunity, columbine makes a beautiful contrast against a dark green background. Notice the large secondary petal at upper left. I left the watercolor pencil untouched there to show the pencil strokes.

Don't let your work become too uniform or it will look as if it were pasted on. This is sometimes a danger with a light subject on a dark background. Try these variations:

- Leave some pencil work untouched—the linear effect is pleasing.
- 2. Lost and found edges integrate subject with background. Here, a damp brush blends colors softly.
- 3. A bit more water creates lovely puddles. I like the fresh, juicy hard edges that form when the puddles dry.
- 4. Keep other areas crisp and clean like this, instead of soft.
- 5. Subtle color or temperature variations are nice, too. The tip of this petal is warmer than some of the other shadowed areas.

Colorado Columbine Watercolor pencil and watercolor on Fabriano hot-pressed paper 7" × 5" (18cm × 13cm)

Artistic Detective Work

In the Adirondacks in June, bunchberry hides under the trees. I drew these in my journal and was able to use my sketch to identify them later (another great use for your artwork).

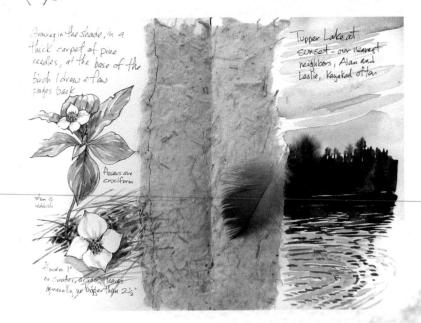

Mountain Wildlife

You may not be lucky enough to get close to wildlife. One solution is to take a camera with a telephoto lens, a pair of good binoculars or a terrestrial telescope with you. It's a bit difficult to draw when using binoculars or a telescope, of course, but it can be done. Resource photos are a big help.

Stuffed mounts can be another useful resource. Some mounts are just ghastly, like stuffed toy animals, certainly not like anything that once had breath! Hold out for ones that look real and, more importantly, alive. Often, a natural history museum will have very good mounts, as will national parks' visitor centers.

Interestingly, places like Bass Pro Shop or Cabela's may also have very high-quality mounts. It's not the same as working from life, of course. If at all possible, you need to put in your time in the field so you have an understanding of the natural behavior and characteristic poses of your subject. But for close work, mounts may be the best solution you can manage.

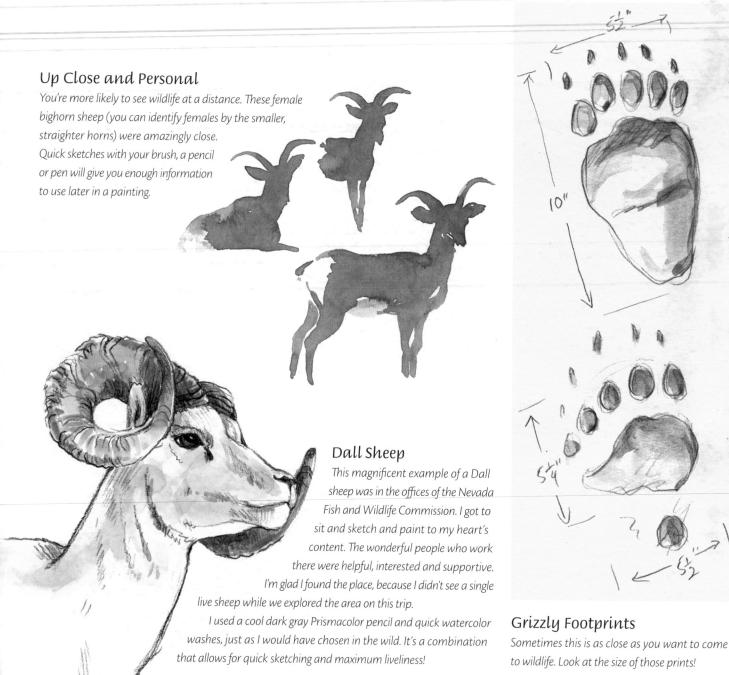

Mountain Sheep

The sheep were very far away, up on a mountain ridge, so I decided to paint them as tiny as they looked on a more abstracted, bold mountain. The contrast of the large, abstracted landscape and the carefully delineated sheep lets the viewer realize how vast this scene is.

MATERIALS

SURFACE

Fabriano cold-pressed watercolor block

PIGMENTS

Burnt Scarlet, Burnt Sienna, Cadmium Yellow Medium, Phthalo Blue, Quinacridone Burnt Scarlet, Quinacridone Gold, Ultramarine Blue, Yellow Ochre

BRUSHES

½-inch (13mm) and 1-inch (25mm) flat no. 1 round

OTHER SUPPLIES

olive green watercolor pencil

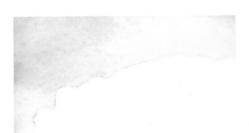

Begin With a Sketch and Add a Wash

I sketched the shape of the ridge with an olive green watercolor pencil, then added a graded wash for the sky, from Cadmium Yellow Medium on the right to Phthalo Blue on the left.

n Lay in Darker Colors

I mixed a strong wash of Ultramarine Blue, Burnt Sienna and Quinacridone Burnt Scarlet and laid it in quickly, following the shape of the ridge. Then while that was still wet, I dropped and spattered in Yellow Ochre and Quinacridone Gold to suggest the desert plants, with a bit of scratching or scraping into the damp wash here and there to ground the plants with branches.

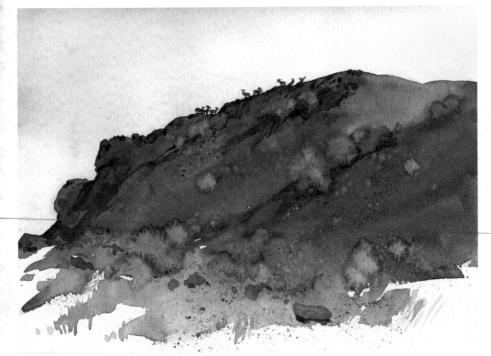

3 Add Details and Shadows Finally, I added details and shadows to the

mountains and painted those tiny, tiny sheep with a no. 1 round and a mix of the same colors used previously.

Mountain Sheep Watercolor on Fabriano cold-pressed paper $9" \times 12"$ (23cm \times 30cm)

Birds of the Mountains

Some birds just seem to make us think of mountains, though you will also find them elsewhere. The bald eagle is really much more common than we might think since the insecticide DDT was banned and nesting is more successful. I've seen them a few miles from my home in the Midwest, fishing on the Missouri River.

Migration does affect bird populations. You may see songbirds from spring to fall, but by winter many of those have gone south.

You probably won't get close enough to a bald eagle to sketch it in this detail, but, if you have a telescope or good telephoto lens, it's possible. Working from a photo makes the impossible doable.

Horned Owls

In the Great Smokies and elsewhere. great horned owls are common year-round. You may find evidence of their nocturnal hunt in the snow by morning's light or find one drowsing in a tree near the trail. Colored pencils are wonderful for quick sketches under winter conditions since no water or other medium is necessary, though you can add a wash later (when you're someplace warm!).

Hummingbirds

These little guys don't often stay still long enough to sketch them, even a rough sketch like this one. Do some quick gesture sketches, then flesh out the details and color with help from a photo or field guide drawing.

Mountain Painting

Adding the suggestion of a bird or birds in the sky gives life to your paintings. It's a very strange day when you see no birds at all.

Wherever you are in the mountains, take a good look to see what makes that particular place unique. What captures its spirit? Mountains and mountain ranges are different. What is it that captures your eye about this particular place?

MATERIALS

SURFACE

Fabriano cold-pressed watercolor block

PIGMENTS

Burnt Sienna, Cadmium Orange Medium, Cadmium Yellow Deep, Manganese Blue Hue, Olive Green, Permanent Rose, Phthalo Blue, Ultramarine Blue, Yellow Ochre

BRUSHES

¾-inch (19mm) flat no. 8 round old, moth-eaten ½-inch (13mm) flat small bristle brush

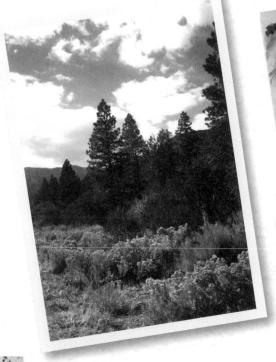

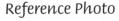

This is Nevada's Mt. Charleston, where there is a great range of flora and fauna, as you'll often find below the tree line. The mountains provide a backdrop to trees, wildflowers and wildlife, making a colorful tapestry. It just cries out to be painted.

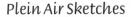

Here is a selection of quick paintings that I did on the spot this past year. From the top: the bare red mountains near Henderson, Nevada; the amazing steep grassy foothills in California, dotted with live oak; the thickly wooded Adirondacks near Lake Durant, New York; and the rugged brown mountains and distant blue vista in the Angeles National Forest, California. Each one is very different from the others.

Brushes

Consider the interesting textures to be created with a variety of brushes, old and new. For this painting I chose, from the left, a ¾-inch (19mm) flat, a small bristle brush intended for oil paints, a no. 8 round and a moth-eaten ½-inch (13mm) flat that's great for textures. I'm glad I didn't throw the old moth-eated brush away!

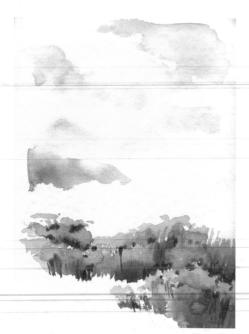

η Lay in the Sky, Mountain and Foliage

To keep this scene fresh, lively and immediate, lay in the sky very quickly, with a combination of Phthalo Blue and Manganese Blue Hue and a %-inch (19mm) flat, leaving dry-brush edges to suggest the puffy white clouds. While the sky is still damp, add the distant mountain with Ultramarine Blue and a touch of Burnt Sienna, allowing the sky wash to touch, here and there, to suggest low-hanging clouds over the mountaintop.

Quickly lay in the yellow flowers and sage green stems of rabbitbrush with the ratty old ½-inch (13mm) flat, leaving the upper edge partly white paper for sparkle.

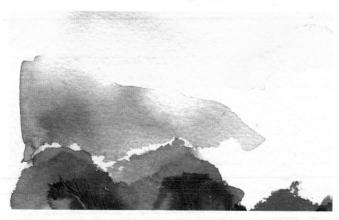

Step 1 DetailThis detail shows the blending between mountain and sky.

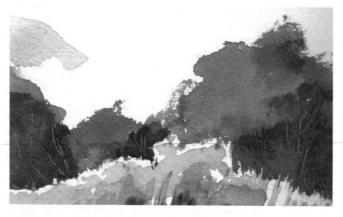

Step 2 Detail

While the trees are still wet, scratch in darker lines to suggest trunks and limbs. Allowing the green washes to dry a bit more will let you scrape the paint back out of the way to look like lighter trunks. Timing is important here, so you may want to practice on scrap paper to get a feel for it.

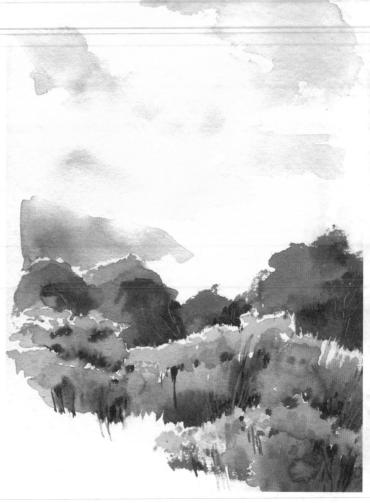

Differentiate the Deciduous TreesA warmer mixture of Yellow Ochre and Phthalo Blue with a bit of Olive Green differentiates the deciduous trees behind the rabbitbrush.

3 Lay in Wash and Spatter
A shadow wash of mostly Phthalo Blue ties the areas together and softens some parts. The mountain on the right is Ultramarine Blue with Yellow Ochre and a little Phthalo Blue, kept very simple but varied a bit to suggest the trees that cling to the slopes.

Some spatter, some more pouncing strokes with that little bristle brush and a few detailed stems painted with the tip of the no. 8 round finish the flowers and foreground.

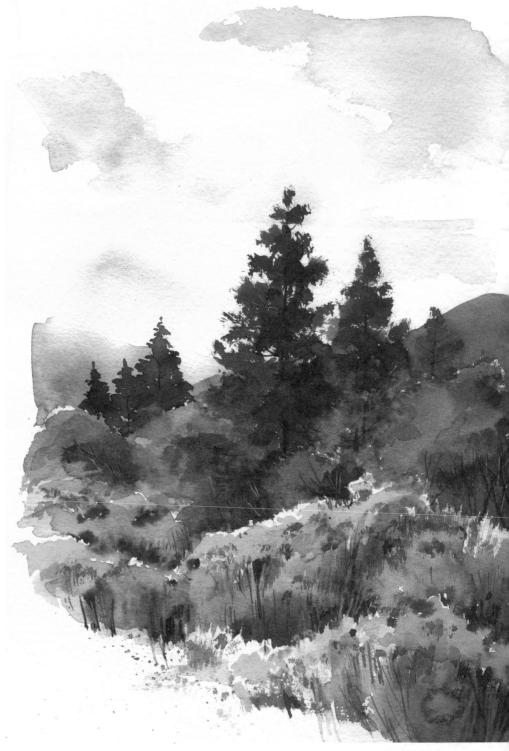

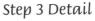

Paint in the lacy evergreens mostly using that handy old bristle brush. Use a pouncing and sometimes scratching motion and a strong mixture of Phthalo Blue and Burnt Sienna, again scraping and scratching through the damp paint to suggest limbs.

With the no. 8 round, paint the more distant trees to the left using a dancing motion of the tip. Keep them a bit lighter and cooler in value to push them into the distance.

CHAPTER EIGHT

Deserts

ere, in the earth's driest areas, we discover a beautiful, austere landscape that can change as often and as rapidly as the passing hours. In shadow or sunlight, in spring or fall or winter, or after the all too infrequent rains, the desert shows us her changing face. A distance of a scant few miles can mean the difference between a brown, serene landscape and one of flaming reds and golds, as in Nevada's Valley of Fire. After a rain, the desert bursts almost ecstatically into bloom, hurrying to put on her best dress before the water evaporates again.

Deep blue, lavender and purple shadows paint the rock shapes, and soft gray-green or desert gold plants blanket the hills. Never imagine that there isn't a great deal to paint here. There is!

Take care when entering this harsh land, even to do a quick sketch. Take plenty of water and wear protective clothing. A wide-brimmed hat will shade you and block the glare from your drawing or water-color paper. Good walking shoes will help a lot, and watch where you put your feet.

As they say in the desert, "Whatever moves will bite you; whatever doesn't will stick you!"

We may think of the colors of the desert as rather simple sand, rock and "cactus green." Throw in a blue for that big sky arching overhead, and your palette is complete, right?

Wrong! Sit back, take your time, and look more closely. Name the colors to yourself, and be as descriptive as you like. Don't feel you have to stick with official pigment names, straight from the tube. Compare with the pigments you normally keep on your palette, and see what's close as is and what needs subtle mixing to approximate the myriad hues of the desert.

You may even want to experiment with some of the new mineral colors, such as those from Daniel Smith.

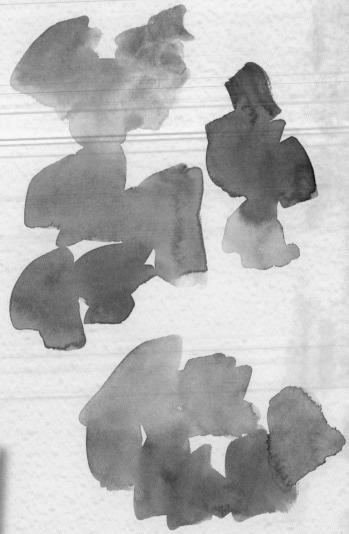

Desert Colors

The earth colors and the blues may be fairly close. Traditional earth pigments are, after all, taken right from the dirt, either as their native color or "burnt" for a richer, darker and usually warmer color. Think of the difference between Raw and Burnt Sienna. The greens are another matter, unless you've bought some fairly obscure ones. I like to use the warm blues to mix desert greens. These mixtures result in a grayer range that's typical of many of these plants. Cobalt Blue and Ultramarine Blue can be handy here.

Here you see Phthalo Blue and Manganese Blue Hue at upper left, with a shadowy purple made of Ultramarine Blue and Cobalt Blue at right. At center left is Quinacridone Gold (a new synthetic color), Burnt Sienna and Quinacridone Burnt Scarlet. At the bottom is a variety of soft mixed greens, some tending more to the yellow, some to the blue, but all softer than most straight from the tube.

Ground Squirrel

Much less shy than the bigger mammals, cheeky ground squirrels are found any place where they might get a handout! They were everywhere near the Valley of Fire State Park visitor center. These were near a picnic shelter at White Domes, a cul-de-sac at the park.

MATERIALS

SURFACE

Fabriano hot-pressed paper

PIGMENTS

Blue Ochre, Burnt Sienna, Hematite, Minnesota Pipestone, Sedona Genuine, Ultramarine Blue

OTHER SUPPLIES

4B Pentalic woodless graphite pencil

Initial Sketches

I sketched as quickly as I could. Although they were curious, they were also quick!

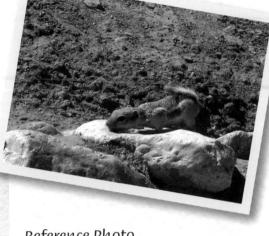

Reference Photo

To supplement your sketches, try to catch these fast-moving little rodents with your camera. My niece offered this one a drink of water in a little depression in the rock, and we suddenly became much less frightening. Two of them vied for drinks, giving me great photo ops.

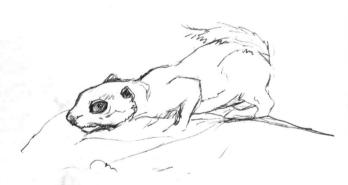

Block in the Basic Shapes

Block in the animal's shape with your pencil. I emphasized the shape here with a rather bold drawing so it would show up in print, but you probably won't want to draw such dark lines.

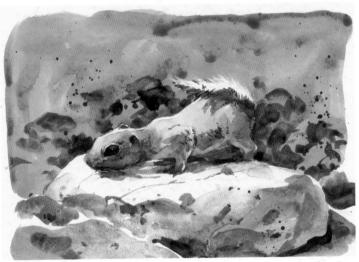

Add Color

I was trying out some new Primatek mineral colors from Daniel Smith. The background is a mixture of Minnesota Pipestone and Sedona Genuine with Hematite—nice, earthy desert colors. I added Blue Ochre in the rocks but chose regular transparent watercolors (Burnt Sienna and Ultramarine Blue) for the squirrel itself.

Desert Wildlife

Depending on where you find yourself, you may see pronghorn antelope, jackrabbits, spotted skunks, coyotes, kit fox or ground squirrel. Ravens are among the most common birds, but roadrunners have earned a place in our folklore as well. You may be surprised to find a house finch or to hear the sweet, liquid song of a canyon wren.

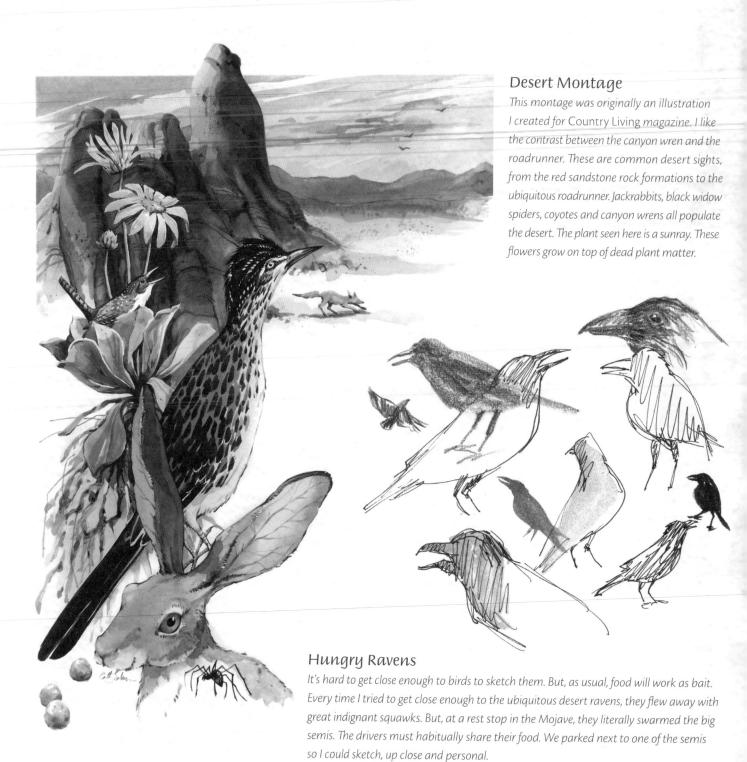

Here, stick graphite, fine-tipped marker, indigo colored pencil and quick watercolor washes

caught something of the ravens' poses and personalities.

Antelope

Like the Dall sheep in the previous chapter, the opportunity to draw an antelope this close presented itself at the Nevada Department of Fish and Wildlife. This is Strathmore watercolor paper with warm dark gray colored pencil and watercolor washes. Take any opportunity you can to draw these creatures at close range.

nose "patch" loose on

Western Patchnosp Snake -

gray and yellow 7

dorsolatoral yellowis

the whipsnake

yellowish

Reptiles

Sometimes it appears that reptiles are best adapted to desert life. All kinds of lizards and snakes make their way in the desert, from the little tan lizard I saw skitter under a rock, to sidewinders (also called horned rattlesnakes) and the docile, nonpoisonous patchnose snake seen in this graphite field sketch.

Reptiles can regulate their body temperature more easily than a mammal can. That's why you see so many of them in desert climes.

Speedy Lizards

To capture a zebra-tailed lizard on paper, you'd better be quick. This was done with an artist pen in brown, with very simple watercolor washes.

A "stick figure" like the one at top may help you to capture the pose. Then flesh it out as you have time. A field guide may help with the markings.

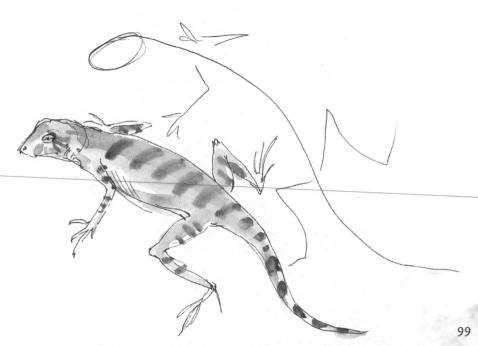

Trying Out Desert-Toned Paper

You may want to choose a tan, sienna, gold or other "desert-toned" paper to work on. Then use some opaque watercolors or gouache, or mix a little white in with each of your colors. The Old Masters used toned papers frequently. It's a technique that's gotten short shrift in more recent times.

The really interesting thing about this technique is that if you choose a mid-toned paper, you can add darker darks and lighter highlights to achieve an almost three-dimensional effect.

MATERIALS

SURFACE toned warm tan paper

PIGMENTS Burnt Sienna, Phthalo Blue, Raw Sienna, Titanium White

BRUSHES no. 7 round ½-inch (13mm) flat

OTHER SUPPLIES black colored pencil

I cropped the foreground, simplified the plants and emphasized the height of the mountains. Never feel that you have to copy a photo exactly; it's a tool like any other, and you're the boss.

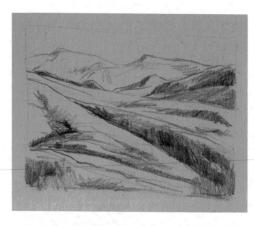

Start BoldlyDo your preliminary drawing more emphatically than usual. I used a black colored pencil. Go as deep and intense as you like with your darks; they form the bones of your painting with this technique.

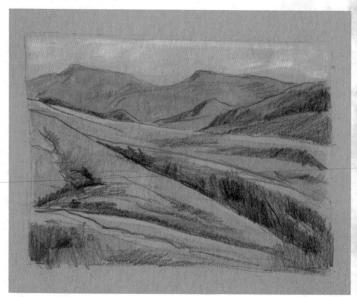

2 Add Lighter Tones

Start to add your lighter tones with local color. You can alter them later in either direction, going lighter or darker. I used a combination of gouache paints and white added to my regular watercolors.

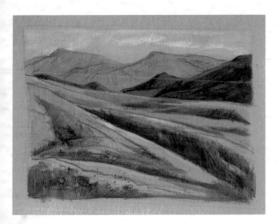

Apply Stronger Washes
Mix stronger washes with less white in them for
the mid- and darker tones. Here, I used Phthalo Blue
with a little Raw Sienna for the mountain that's mostly
in shadow, and a stronger mix of Raw Sienna and a
little Burnt Sienna for the foreground gullies. See how
rounded it's beginning to look?

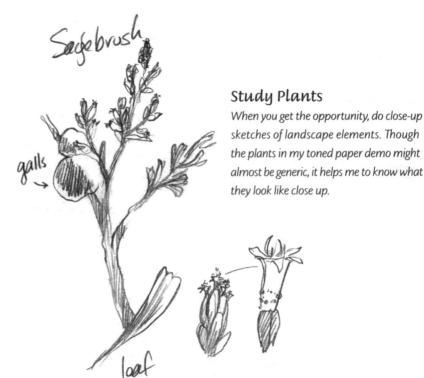

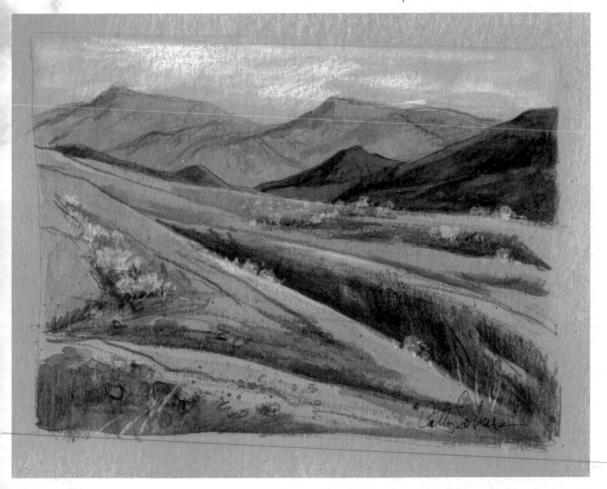

Desert Erosion Watercolor, gouache and colored pencil on toned drawing paper $5" \times 7"$ (13cm \times 18cm)

Lighten and Darken the Details
Keep adding lighter lights for the sagebrush and other desert plants with quick, lacy strokes. Add deeper darks where needed. I used a little pale colored pencil in the sky and restated some of the dark lines with my black colored pencil.

Signs of Early Occupation

Ghost towns, old ranches and claim shacks are common in the desert Southwest. At one time, all you had to do was build some sort of structure on a piece of desert to claim it as your own. You can still see many of these shacks, shanties and cabins as you drive through the Mojave and Sonoran deserts between California and Nevada. In some areas, there are whole towns, now abandoned, full of picturesque and evocative buildings to paint.

Even earlier marks of human settlement are graven in the rocks in many areas. Petroglyphs, scratched through the dark "desert varnish" hundreds of years ago, still speak to us in mysterious whispers. For one thousand to fifteen hundred years, the Anasazi, the Hohokam and

other peoples made their homes here. It seems they communicated with one another or commemorated great events of their lives with these markings, or maybe they were just an earlier version of graffiti! You may see images of bighorn sheep and other animals, hands, ladders, lightning shapes, humans, concentric circles and even spirals virtually identical to those at Newgrange, in Ireland.

The petroglyphs on Atlatl Rock in the Valley of Fire State Park are believed to be three thousand to four thousand years old, but those at Mouse's Tank, not far from the visitors center, are thought to be Puebloan in age, approximately eight hundred to two thousand-years old. There are subtle differences to study here.

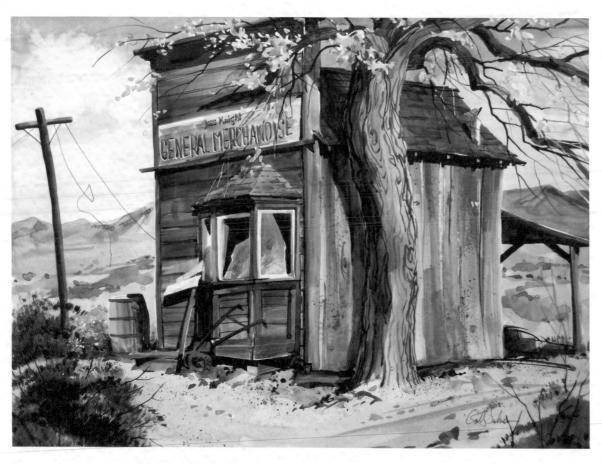

General Merchandise Watercolor on hot-pressed par 11" × 22" (28cm × 56cm)

Desert Stress

You may find yourself working more quickly in the desert. You must hurry to beat the dry air that sucks the moisture out of your washes and dries your paper unevenly, and you'll put on the speed to finish when it's uncomfortably hot. This painting of one of the abandoned buildings in the desert was done rapidly, with a very strong, calligraphic feel. Happily, it worked well with the subject.

This is very smooth hot-pressed paper. It lends itself to some wonderful texturing effects. Notice the sagebrush at lower left that was done with a bristle fan brush, trimmed to a jagged "hairdo" for interesting, spiky textures.

A technical ink pen with a fine nib worked wonders for the broken wires, drawn smoothly on the hot-pressed paper.

Work Light to Dark

When painting this type of subject matter, one of the best approaches is just the opposite of the way the original petroglyphs were made: Work light to dark, rather than scratching or pecking through a dark layer. Try laying down a reddish underwash, allowing it to dry. Then, use a resist-like wax or masking fluid before painting on a much darker, cooler shade to represent the desert varnish.

Here, the spiral was done with a little white birthday candle. The ladder was drawn with a white colored pencil, and the hand petroglyph was done with masking fluid, painted on and allowed to dry before adding a second wash of Burnt Sienna, Phthalo Blue and Ultramarine Blue. All three give very different effects, as you can see. Remove the masking fluid when this wash is dry and finish up with spatter or fine lines to suggest the cracks in the rock. You'll be amazed at the effect.

Petroglyphs

These are some of the Puebloan petroglyphs near Mouse's Tank in Nevada, done with much the same progression as above.

Petroglyphs
Watercolor on Fabriano cold-pressed paper
5" x 7" (13cm x 18cm)

Desert Plants

You may picture little more than cactus and sage when you think of the desert, but wait! When you look with fresh, unbiased eyes, you'll see a great variety of plants, colors and shapes.

After a rare rain, the desert bursts into bloom. Yellow, white or pink flowers may be seen. Even the Joshua tree blooms, as do the ancient saguaro cacti. Mojave yucca stands tall on the debris of years past, raising a staff of beautiful white flowers. Even when it hasn't rained, you may still see a variety of interesting and beautiful plants to capture your painter's eye.

Мојаче Үисса

Watch for distinctive shapes and growing habits. The Mojave yucca looks very different from the yucca plant in my Midwestern yard.

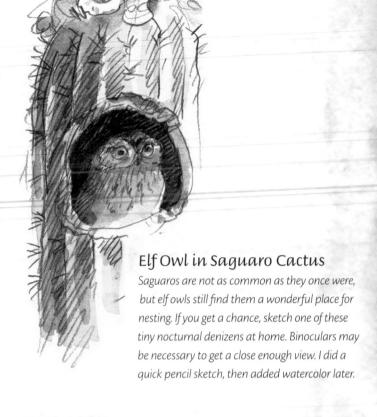

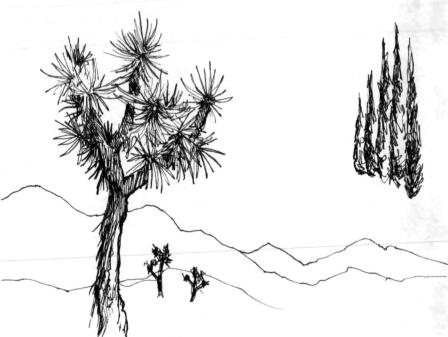

Desert Shapes

Look at the variety of shapes around you. The many-branched Joshua tree contrasts dramatically with the upright spires of juniper. Try a fine-pointed pen and a quick emphatic line to capture these shapes.

QUINACRIDONE BURNT SCARLET

BURNT SIENNA

YELLOW OCHRE

RAW SIENNA

QUINACRIDONE GOLD

PHTHALO BLUE

COBALT BLUE

Palette Peek

You might have guessed that I used a fairly limited palette for Desert Plants (below), but look how many colors went into the mixtures. Be careful with your choices, and don't try to mix too many pigments into any one wash. Don't be afraid to use bold colors, even to achieve subtle effects.

Look at Details

Notice the interesting jointed shape of the Mormon tea in this close-up. I love to pay attention to details like this.

Close-Up Study

If you get the chance, do a field sketch of the details. You get a much better idea of the life cycle of the plant if you can study it up close. Here you can see detailed studies of the flower, fruit and leaf of a Joshua tree.

Compare and Contrast

If you have the luxury of time and a comfortable place to work, consider a detailed study of the plants you find in a given habitat. These were clustered at the base of a Joshua tree near Hesperia, California.

Here, one of the buckwheats is on the left, with a composite in the center and Mormon tea on the right. The large sword-shaped leaf is from the Joshua tree.

Desert Plants Watercolor on Fabriano hot-pressed paper 9" × 12" (23cm × 30cm)

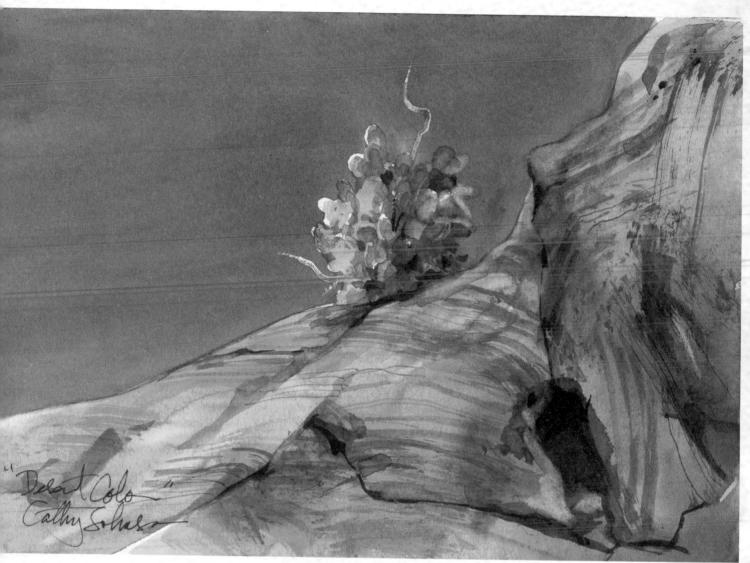

Desert Color
Watercolor on Fabriano hot-pressed paper
5" × 7" (13cm × 18cm)
Collection of Laura Murphy Frankstone

Survival Tactics

In the desert, everything must adjust. There's little rainfall, and plants have evolved to be able to find water in the low spots and gullies and hoard the water they have found. They may have furry leaves, dry woody stems or succulent bodies. They make use of any number of survival tactics, but survive they do and under amazingly harsh circumstances!

This little plant, silhouetted against an impossibly blue sky, was growing from a tiny crack in the rock, high above any source of dependable water.

Palm Trees

Palms really do grow in a desert oasis or where they're watered regularly. There are many different kinds to draw and paint, some native, some imported and all interesting. The large one here is in watercolor. The other small ink studies are for comparison.

Raven's Hole

Remember, when painting in the desert the light is often intense. (So is the heat, of course, during a large portion of the year.) Shade is at a premium. There are few large trees to find shelter under, but it is cooler in the shade of a large rock.

The strong, clear light may make it difficult to judge color or value, especially if your paper or palette is in the sun. Try to keep them both in the shade to have a better idea of what you're mixing. Sometimes all you have to shade your work is your own body. In that case, you're probably going to be working really fast!

MATERIALS

SURFACE

Strathmore cold-pressed watercolor block

PIGMENTS

Burnt Sienna, Manganese Blue Hue, Quinacridone Burnt Scarlet, Raw Sienna, Ultramarine Blue, Yellow Ochre

BRUSHES

barbered fan brush old, moth-eaten ½-inch (13mm) flat small stencil brush

OTHER MATERIALS

Tuscan Red colored pencil, Venetian Red watercolor pencil

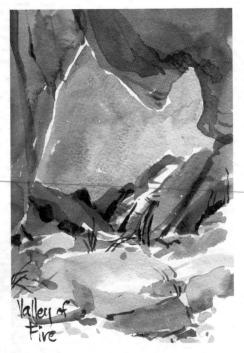

Value Sketch

There's no need to use black for a value sketch if another color is at hand or suits your subject better. In this case, the dark Tuscan Red colored pencil seemed to fit my proposed subject. I made a small value scale to the right of the thumbnail sketch to help firm my awareness of the values I intended to use in the painting.

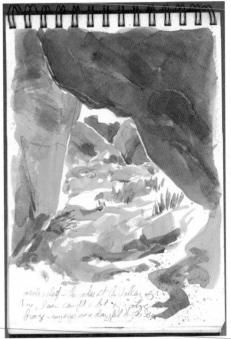

Quick Sketch

You may want to work smaller or use small washes (barely larger than a stroke) to beat that drying speed as I did in my second attempt. This one is in my $7" \times 10"$ (18cm \times 25cm) Strathmore watercolor sketch journal.

Later, when the light was more moderate, I adjusted the values so you get the feeling of looking out from a shaded place into that bright desert light. I used mostly Ultramarine Blue, Quinacridone Burnt Scarlet and Burnt Sienna for the shadowed rock, texture and spatter.

Harsh Sunlight

I was in a tiny patch of shade where there wasn't room for both my palette and my small watercolor block. Looking back and forth between them and the brightly lit scene made it almost impossible to judge colors or values, but, just the same, there's something here that catches the spirit of the place. It's a small painting, 5" × 7" (13cm × 18cm), but even so the washes dried very rapidly.

Sketch With Watercolor Pencil I decided to use watercolor pencil for the preliminary drawing on watercolor paper so the lines would disappear, unlike pencil lines. The color I chose (Venetian Red) really didn't lift that well when wet, but it blended in better than graphite. (Slightly off-white paper is difficult to reproduce, so the paper looks darker than it is.)

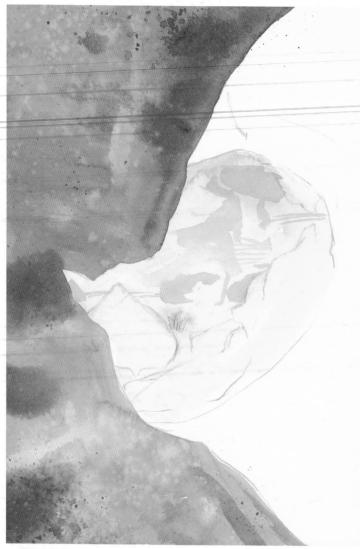

Work on Values Getting the values right is extremely important with a subject like this. You need strong contrasts to depict hot desert sunlight. Keeping those first washes light enough is difficult but necessary. I used Yellow Ochre with just a touch of Quinacridone Burnt Scarlet in a very high-keyed wash.

2 Deepen the Colors

To make sure I had the shadowed value dark enough, I did a swatch on a piece of scrap paper. Then I went ahead with a mix of Burnt Sienna, Quinacridone Burnt Scarlet and a little Ultramarine Blue, keeping the edge closest to the light in deep shadow.

While that was still wet, I dashed in some almost full-strength Quinacridone Burnt Scarlet and Ultramarine Blue, and let it dry until it began to lose its shine. Then I sprayed it lightly with clear water and blotted with a tissue, just to give the wash some sandy texture. I lifted a few highlights with the folded edge of a tissue to define the rock shape.

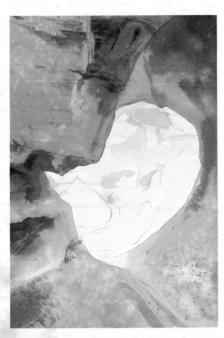

Adjust the Values at the Top

It was getting a little tricky by the time I got to this step. The top needed to be a darker value than the closer rock on the left or the lower part of the opening. To make sure things went relatively smoothly, I wet that whole section with clear water twice to more or less soak the paper. I then allowed it to begin to lose its shine and added a strong wash, using the same colors as before.

I began at the top with a stronger mix of Quinacridone Burnt Scarlet and a lot of Ultramarine Blue. I then added more water and less blue as I proceeded down the page. Some wet-in-wet variation was introduced for interest, and I tipped the paper this way and that to encourage the colors to flow together.

I added the clear water spatter again, this time concentrated at the bottom. Since the top was really quite shadowed, not much detail was needed there.

A bit of Manganese Blue Hue and Raw Sienna made a nice lichen color, which I spattered on with a small stencil brush.

I also began adding dry-brush details on the left side, following the direction of the rock's striations. A barbered fan brush and my favorite old moth-eaten brush worked well for most of this.

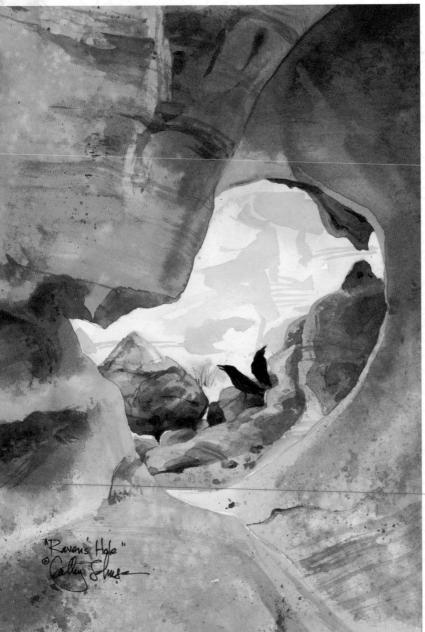

Add the Final Details

I added more detail to the walls and added the jumble of rocks in the opening, paying attention to where the light fell on them and modeling them with shadows and highlights.

A bit more warm and dark spatter added texture. I used a photograph I had taken of a pair of desert ravens, perched on the side of a canyon wall, as a resource photo. They offer a focal point where the lightest lights and darkest darks meet, emphasizing the effect of strong desert light beyond them.

TIPS

The paint on your palette and in your wash wells dries more quickly, too, so you'll learn to mix more than you think you'll need. And, again, work quickly. Be sure you have sufficient water with you, both for drinking and for painting.

Raven's Hole Watercolor on Strathmore cold-pressed paper 9" × 12" (23cm × 30cm)

CHAPTER NINE

Humans in Landscape

It's a delightful challenge to include people in our paintings. If not literally the human form, then sometimes the marks of our presence is enough—a discarded fishing lure, an old bridge or a heart with initials carved into a tree, as lovers used to do.

Including the human in one way or another can make nature more accessible, less primal or austere. (Of course that can be good or bad, depending on your viewpoint.) It can also offer a sense of scale—you'd never know how big some natural objects are without the human form to measure them against.

Lost Lures

It's funny how often fishermen lose their lures, snagging them on unseen obstructions. I've found all kinds.

Graham Cave

Evidence of human use dating back ten thousand years has been found in Missouri's Graham Cave, near Interstate 70. It may have provided shelter for an entire village who found the nearby Loutre River a rich source of food—the small human figure gives an idea of scale. I created this sketch with sepia ink.

Heart Tree

It took me a full day to notice this heart, carved long ago in the tree by our campsite. Since it was our first camping trip together, I found it rather romantic.

Relative Size

If you have trouble judging the relative size or proportion of the human you want to include in your landscape, take its measure.

Keep it simple! Use any handy tool, like a pencil. Align the tip with your subject's head, then move your thumb down so it's on a line with the feet.

Now compare that measurement with others in the scene you're drawing, still using your thumb and the pencil. How much smaller is the human figure than that rock, tree or whatever? Transfer those proportions to your art.

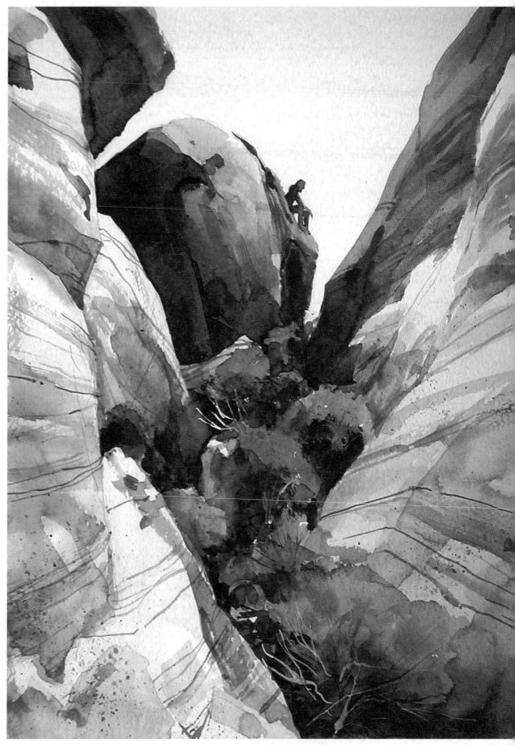

Ascent
Watercolor on Fabriano cold-pressed paper
14" × 11" (36cm × 28cm)

On a Grand Scale

Would you realize how huge these boulders are if not for the climber perched high on the distant rocks?

Going Camping

Whether you camp in a huge RV, a tiny travel trailer, a tent or just out under the stars, there's nothing like leaving your cares behind and settling into a different, slower and more natural rhythm. Exploring the area, sitting by a campfire at night, cooking over the coals, sleeping surrounded by the sounds of the wind in the trees or owls on the hunt—it all puts us in touch with an older, simpler part of our nature. And as has been noted, humans are the only animals who use fire—to cook, to give us comfort, to harden our pottery, to let us dream, to drive back the darkness. It speaks to us.

Camping in a tent is becoming relatively rare as more and more people opt for RVs and travel trailers. Still, almost any large campground will offer tents in a variety of shapes and styles, from a simple wedge-shaped pup tent to a geodesic dome to a marvelous construction with a couple of rooms, including a screened "porch"!

There's something magical about camping in a tent, with only a thin layer of fabric between you and the night and the weather. It's both atavistic and intimate—you're aware of changes in the weather in ways you never are under more emphatic cover.

When you walk through the campground at night as people are preparing to turn in, flashlights and other light sources inside the tents make the structures glow like huge Chinese lanterns. It's an enchanting sight.

Fiery Sunset

This is the first layer in a little sketch of fire against a New York sunset. I was waiting for my love when I noticed the lovely, simple scene and held it in my memory till I could get back to camp and paint it in my journal.

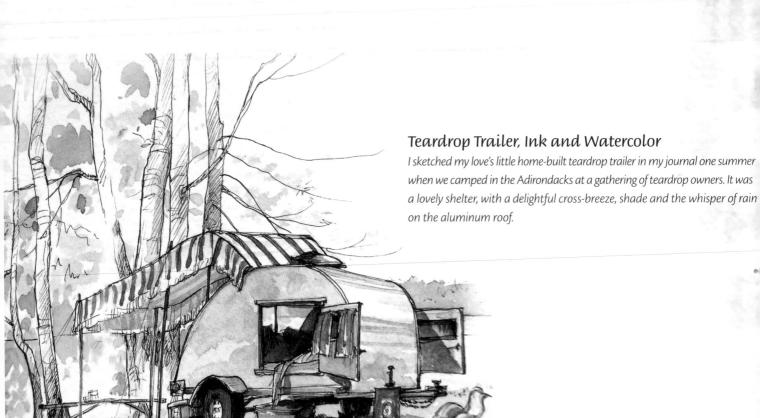

Evening Campfire, Fish Creek

If you're not satisfied with your first effort, analyze what you didn't seem to capture and try again, either directly on the original or on another sheet of paper. Initially, this sketch was too pale and wimpy, and didn't catch the drama. Months later, I could still see those dark trees and the glow of the fire in my mind's eye, so I went back and darkened it considerably.

Campfire Detail

I lifted back the smoke with a dampened bristle brush and blotted the loosened pigment with a tissue, then added a bit of sparkle and life with colored pencils to suggest the warm light on the trees.

Tent Shapes

From the classic wedge shape to the more complicated models with internal or external frames, the basic technology is the same. Just a layer of fabric between you and the great outdoors. Try sketching the various shapes you find.

Tent Camp, Watkins Mill

If there's a campground near where you live or vacation, you can often find any number of subjects. I liked the shape of this large tent—almost like a canvas "house."

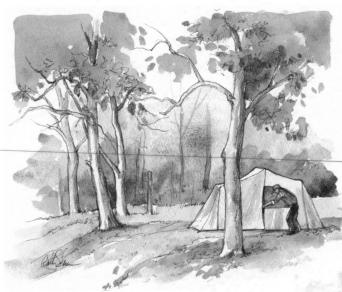

Canoes, Kayaks, Dories and Jon Boats

Watercraft are wonderfully satisfying—to watch, to travel in and to paint. They're marvelous to paint from as well. They act almost as a kind of blind (or "hide," as they say in Europe) to wildlife, which are much less likely to pay attention to you gliding by in a nearly silent canoe than if you approach on foot. Something about our tell-tale two-leggedness makes most creatures wary!

In the coastal regions, you're liable to see boats everywhere—up on scaffolds, beached, bobbing in the water, on top of your neighbor's car. Their shapes are endlessly fascinating. These forms look decep-

tively simple, but, in fact, they're subtle, elegant and rather complex. When my love and I were at the Adirondack Museum, we visited the display of canoes and guideboats, and were blown out of the water (if you'll excuse the pun!) by the delicate subtleties of shape that make all the difference in how a watercraft handles and what it's intended to do. Even in the subcategory of "canoe," you have whitewater craft, canoes for relatively still water, canoes stable enough for families and canoes for adventurous individuals—and more. Catch those shapes accurately, and your work will ring true!

Maine Fishing Boat

Notice the sweep
of the bow on this
fishing boat and
the follow-through
indicated by the dotted
line. That was very difficult
to catch properly, but the
shape makes it much more believable than if I hadn't
shown the tip of the bow rising above the gunwales.

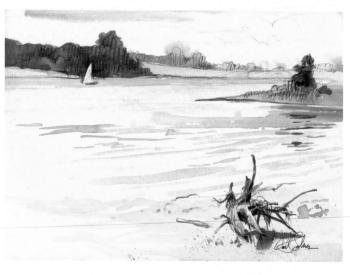

In the Distance

If the boat is far enough away, you can barely see the people—in this case represented by the red dot of the windbreaker the sailor wore.

Sailboat at Watkins Watercolor on Fabriano cold-pressed paper 9" × 12" (23cm × 30cm)

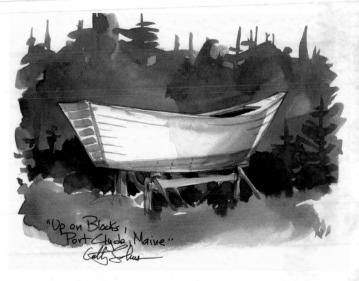

Dry Dock

I drew the shape of the boat and scaffolding as carefully as possible in pencil, then painted the negative shapes around it, first the trees in the background and the grass underneath. The background was a bold, varied mix of Phthalo Blue, Burnt Sienna and a bit of Yellow Ochre in the lighter green areas; the foreground leaned more heavily on Yellow Ochre and Cadmium Yellow Medium in the mix.

Then I added the details of the scaffold, paying attention to lights and darks, and finally the shape of the boat itself. I tried to capture the roundness at the bow, especially, keeping values mostly light so the boat would stand out from the dark evergreens behind it. The deep dark shadow inside the boat gave it dimension.

You can use boats as smaller elements in your landscape or seascape. If they're in the middle ground or distance, their shapes can be greatly simplified. Be aware, though, that the eye will be drawn directly to them, so do try to get those silhouettes right.

Up on Blocks, Port Clyde, Maine Watercolor on hot-pressed paper $5" \times 7"$ (13cm \times 18cm)

Sunset Canoes

Our local state park closes at sunset to all but those camping there, so I hurried to capture my impressions of the scene as evening fell. I was far from the parking lot, so working fast was a necessity.

MATERIALS

SURFACE

Fabriano hot-pressed watercolor block

PIGMENTS

Burnt Sienna, Quinacridone Burnt Scarlet, Ultramarine Blue

BRUSHES

no. 2 round small flat bristle brush

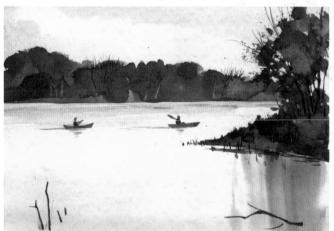

Apply Wash and Capture Reflections

Here, I laid in a single variegated wash for the sky and the water and allowed it to dry thoroughly. I used mostly Ultramarine Blue, Burnt Sienna and Quinacridone Burnt Scarlet for the far hillside. While it was still wet, I used the tip of a mechanical pencil to scratch fine lines in it to represent limbs. As it began to lose its shine, the end of an aquarelle brush pushed lighter lines out of the dark wash.

I used a cool, broken wash on the distant water. Then I re-wet the right foreground and stroked in the reflections, using the same colors as above, in a more neutral mixture.

Add the Details

I used a stronger, darker mixture of the same colors to add the bank and trees on the right. The extra detail shows that it's closer to the viewer. Using a no. 2 round, I painted in the two canoeists. Letting color flow wet-in-wet gave them dimension without too much detail.

Finally, I lifted and softened the reflections and the side of the trailing canoe with a bristle brush and clean water, blotting up the loosened pigment with a tissue. Then I added a few more sticks, water weeds and their reflections.

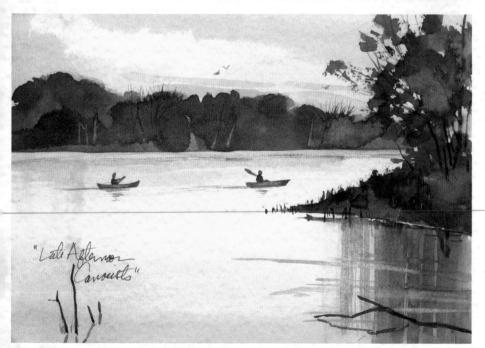

Sunset Canoes
Watercolor on Fabriano hot-pressed paper $5" \times 7"$ (13cm \times 18cm)

Fishing

I was raised by a dedicated fisherman. Year-round, my dad was out there, rod in hand. My sister tells me that whenever he'd visit her out West, they'd go for a drive and he'd invariably say, as they crossed a river, "A man could catch a fish in that stream . . ." Knowing my dad, he probably could.

Consequently, I have a soft spot in my heart for the sight of a person fishing. Childhood fish fries nourished more than my body.

Dominating Hard Edges

This little guy's cute, with his hard-edged colorful washes, but he'd really take over this little painting.

Fishing Watercolor on rough paper 3" × 4" (8cm × 10cm)

also and the second sec

Overcast Day

This fellow was fishing from an aluminum Jon boat at Watkins Mill State Park. It was an overcast day and the fish seemed to be biting like mad.

I used the tip of a round brush and a lacy, dancing stroke to suggest the foliage at left as well as the tops of the trees on the far shore. A bit of scratching with the tip of a sharp craft knife augmented the dry-brush sparkle of the water.

Detail

I introduced a bit of brighter color here and there while the wash was still wet and let the color spread naturally. This works better than hard, sharp washes when you want the figure to complement your painting. When the washes were dry, I refined the details a little with dark shadows in the figure and the boat.

Fly Fishing

We pulled into a rest stop with a glorious view so I could paint and my fiancé Joseph could try fly fishing in the Hudson River. I didn't know how long we'd be there, or how long he'd be in one place; like most fishermen, he tends to try out different holes. So, I used one of my favorite techniques, sketching with a fine-tipped marker with waterproof ink, then adding watercolor washes until I ran out of time.

Hiking or Walking in All Weather

Human beings on a walk is a common sight for most of us. We see them alone, in pairs or in family groups—even gaggles! It's fun to include a person or two in your landscape—again, it offers a sense of scale and accessibility, as well as a focus for your composition.

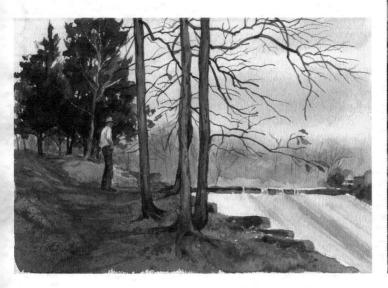

Waiting

My late husband made such a great subject. I loved the focal point his tall, skinny figure made in this landscape near a little Ozark dam. He seems to be waiting for us to catch up with him and discover what's over that little rise.

Harris by the Dam
Watercolor on Fabriano cold-pressed paper
9" × 12" (23cm × 30cm)

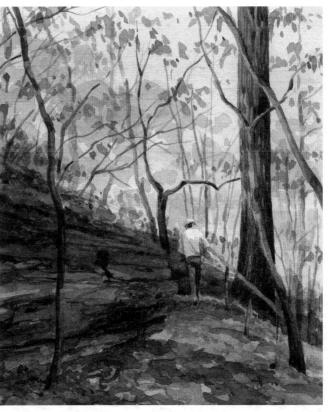

Nature Hike

I was inspired by Thomas Aquinas Daly's beautiful, atmospheric watercolors and just had to try his layered approach.

Harris Hike Watercolor on Fabriano cold-pressed paper 12" × 10" (30cm × 25cm)

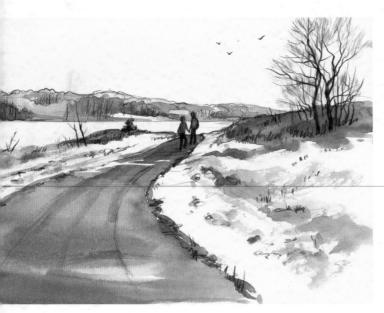

Winter Walk With Watercolor

This wintry landscape is warmed and humanized by the addition of the two walkers just at the crest of the hill. I sketched them with a warm, dark gray colored pencil on Fabriano cold-pressed paper.

The bold colored-pencil sketch provides a framework that frees me to loosely splash on the watercolor. I use wet-in-wet blending and paint just outside the lines on purpose to avoid the coloring book effect. The people are drawn with few lines and then painted just as simply.

Winter Walk Colored pencil and watercolor on Fabriano cold-pressed paper $9" \times 12"$ (23cm \times 30cm)

Small-Scale People

Some artists are intimidated by painting people, but figures can be kept quite simple. Often, we're not trying to do a portrait of a specific human—we just feel our landscape needs something more dynamic.

Take it from the ground up. Even if you're a pro, it's fun to practice with little stick figures. Try out different positions. You can always flesh them out and dress them up however you want later.

Stick Figure Fun

Remember how much fun stick figures were when you were a kid? They still are! See how much action or attitude you can give them. Flesh them out with geometric forms, or dress them up and give them work to do. Next thing you know, you've got people to populate your paintings.

Geometric Shape Figure

If you want to work closer or try a pose that's a bit more complex, you may want to sketch it out first. Visualize the figure as a series of ovals, rectangles and cylinders. I dressed her up a little with colored washes, but you can see the construction lines underneath.

Drawing a Crowd

You don't even have to sketch your figures first, just jump right in with water-color. You can achieve a distant crowd scene with fairly simple dashes. Vary your colors, add arms and legs on some of the figures at the edge, dress them with spots of color and there you have it—a crowd.

Tone Figures

If you prefer, make simple forms using tone. Use a graphite stick, a rolled-paper stump or tortillon, or even a watercolor wash to suggest little people shapes. No features or other details are necessary.

People Shapes

Your people can be neat little silhouettes with fairly accurate proportions (see the three in the upper left) or more colorful, freer silhouettes like the young dancers at right. You probably won't see little green women out on your rambles! Try a more subtle hue and place your figure in shadow and it'll look fine.

The middle ground might have more fully realized figures, like those on the bottom left, but they're still very simple.

Landscape With Figure

Now, try a landscape with a figure in it. Here, I got to paint my niece Jenny in the Nevada desert. It was hot, hot, so I pushed the colors somewhat to get that blazing, bleached idea across.

MATERIALS

SURFACE

Strathmore cold-pressed paper

PIGMENTS

Burnt Sienna, Phthalo Blue, Quinacridone Burnt Scarlet, Ultramarine Blue

BRUSHES

no. 5 round

1/2-inch (13mm) and 3/4-inch (19mm) flat

Resource Photo

I took the photo after Jenny had already retreated to the shade. The perspective is a little different from my sketch, but it still serves as a reminder of the landscape.

Thumbnail Sketch

A very quick thumbnail sketch helps me decide on composition, position and values.

Lay Down Initial Washes I didn't have any masking agent with me,

I didn't have any masking agent with me, so I just had to sketch in her figure and paint around it—needless to say I was working at top

speed, both because of the heat and because of the way washes dry fast in the desert! Working wet-in-wet isn't easy when the arid desert air sucks up any "wet" you have.

This first step consists of getting the initial washes down. I used Phthalo Blue in the sky, plus Burnt Sienna, Ultramarine Blue and a bit of Quinacridone Burnt Scarlet. Details and values can be adjusted as we go along.

Add Details

When those first washes were dry, I completed the figure with simple, expressive shapes and continued to define the linear forms in the rocks. In this step I used stronger mixes of the same colors that I used in step 1. A little spatter in varied warm tones suggested the small rocks and gravel of the desert floor.

Jenny in the Desert Sun
Watercolor on Strathmore cold-pressed paper
7" × 10" (18cm × 25cm)

Implied Humans

You don't actually have to see the human beings in a painting to sense their presence. This idea bothers some who prefer nature untouched, but it speaks to me. In Nevada's Valley of Fire stand a number of tiny rock cairns, placed there perhaps to say, "I was here." Ten thousand years ago, in this same place, humans left their evocative marks on the rocks themselves (see page 103).

Most often, our human marks are less mysterious: an old fence, a derelict barn, a lighthouse or a log cabin in the mountains with a thin finger of smoke rising from the chimney. These things provide a focus for our souls as well as our art.

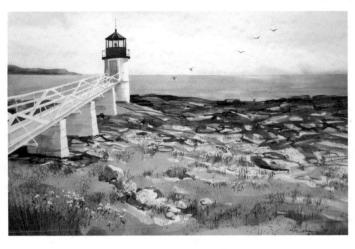

Marshall Lighthouse Watercolor on Fabriano cold-pressed paper 15" × 22" (38cm × 56cm)

Walkway

The human presence is implied in the lighthouse and catwalk.

Maine Roof
Watercolor on Strathmore rough paper $11" \times 14" (28cm \times 36cm)$

Roof Sculpture

Here, the roof in Port Clyde, Maine, where I taught one summer is not the only hint of the human—the gull on the nest is in fact a man-made metal sculpture.

Cabin

The cabin is in Elizabeth Furnace State Park, Virginia. In reality, no one lives there and there was no smoke rising into the November sky. I painted it on the spot as the skies threatened to open up and rain. I imagined how welcoming a cabin with a warm fire would be.

Elizabeth Furnace Cabin Watercolor on Strathmore rough paper 9" × 12" (23cm × 30cm)

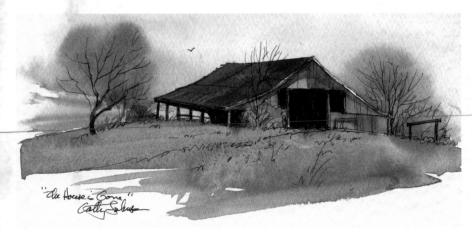

Barn Sketches

If you have spent much time in the country, you know how integral barns are to rural life, the backbone of our heritage. Animals and people share these simple, rugged forms. They have a special ambience, inside and out. They are a vanishing sight, as the countryside becomes the new suburbia. I try to preserve a record of as many of them as I can find.

Watkins Barn Ink and watercolor on Cartiera Magnani cold-pressed paper $7" \times 10"$ (18cm \times 25cm)

Variations on a Theme

Sometimes a painting seems to need some preplanning and "what-ifs" before you can decide how you want to proceed with the finished work, especially if you are working after the fact rather than on the spot.

It was evening on Fourth Lake in New York, and Potash Mountain caught the last warm rays of the sun at the summer solstice. My love cast his line into the lake nearby. I hurried to catch the image in my journal. Since we didn't have the luxury of another sunset in that location, I shot a quick resource photo as well. The sketch is in a vertical format, the photo is a horizontal one. Which to choose, and what colors? I did some preliminary sketches to help me decide.

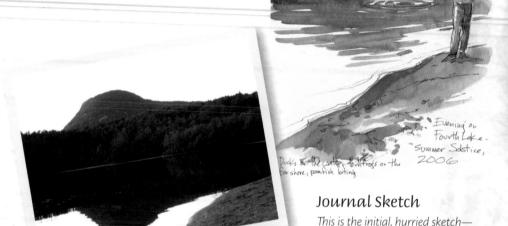

Potash

MATERIALS

SURFACE

Strathmore cold-pressed paper

PIGMENTS

Burnt Sienna, Cadmium Red Medium, Cobalt Blue, Dragon's Blood, Phthalo Blue, Transparent Yellow, Ultramarine Blue

BRUSHES

nos. 5 and 8 round ½-inch (13mm) and ¾-inch (19mm) flat

OTHER SUPPLIES

indigo colored pencil, craft knife, palette knife, masking fluid

Resource Photo

Joseph had already left to go start the fire for dinner, but I stayed a bit, enjoying the peace and shooting resource photos.

Format Sketches

I used indigo colored pencil to explore portrait and landscape formats. Both would work well.

the light was fading rapidly!

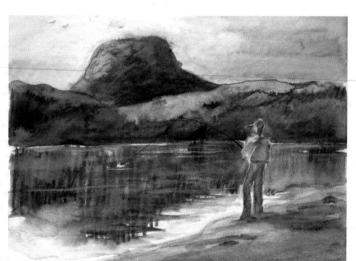

Watercolor Pencil Sketch

In this quick watercolor pencil sketch, I explored the horizontal format as well as a more colorful possibility, pushing what I saw just a bit toward an earlier time of day. Though the format has possibilities, I decided the vertical is more exciting, focusing the attention on that odd mountain in the background.

Apply the Mask and Initial Washes For the sky Jused a graded wash from a warm sunset hi

For the sky, I used a graded wash from a warm sunset hue made up of Cadmium Red Medium and Transparent Yellow, to a cooler blue mixed with Cobalt Blue and Phthalo Blue. I applied these colors with a ¾-inch (19mm) flat.

I protected the figure of the fisherman with masking fluid, applied with a small, inexpensive brush. The masking fluid on the fishing line was laid in with the edge of a palette knife. I used a no. 8 round to paint in the mountain, using the same colors as the sky, with the addition of a bit of green, letting the lower edge of the mountain fade into the trees in the middle distance. Then I repeated some of the warm color in the foreground water.

When that was completely dry, I was ready to paint the middle ground. Strong, variegated washes of Phthalo Blue, Ultramarine Blue, Burnt Sienna and Transparent Yellow suggest the distant shoreline. I paid close attention to the location of the shadows and the lightstruck areas. The ½-inch (13mm) flat worked well for most of these additions.

Notice the clean horizontal where the far shore meets the water. A distant lake shore will almost always look straight and flat.

Paint the Water

Using mostly a strong Phthalo Blue, Ultramarine Blue and Burnt Sienna mixture, I painted in the water, leaving a bright sparkle of white at the distant shore and trying for broken ripples in the mountain's reflection. A bit of lighter green introduced while that bold wash was still wet suggested the reflections of the lightstruck trees. The ½-inch (13mm) flat gave me the most control for these details.

I was nervous about how protected the figure actually was. Notice how dark the blue looks over his face—I wasn't sure I'd put the masking fluid on thick enough.

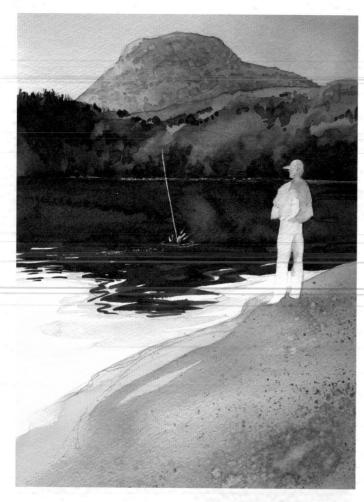

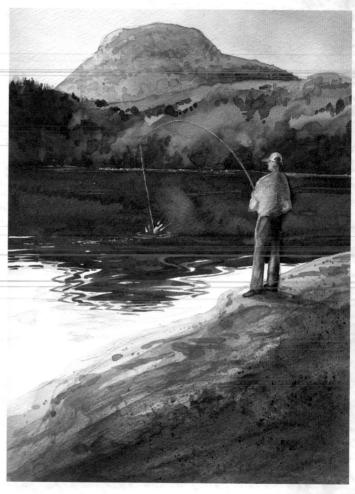

Add Beach Sand
The foreground beach was
very fine sand. I painted it with
a ¾-inch (19mm) flat and a varied
mixture of Cobalt Blue, Ultramarine
Blue and Dragon's Blood, which is a
very warm Burnt Sienna-like color.
Quinacridone Burnt Scarlet will
work as well.

I added clear water spatter as well as spatter in stronger mixtures used for the sand itself. The mountain and tree-lined shore got some detail now, too.

Alter the Values

Hurray for computers and photo-editing software! I wasn't quite happy with the value of the beach, the mountain or the figure (they were a bit too pale and delicate), so I pulled the image into a photo-editing program and did a little preliminary tweaking with the burn tool, just to see how it would look if the beach and figure were darker, as well as the shadowed side of the mountain. I liked it, so I went ahead and altered the painting's values as well.

Figure Detail

I was relieved to find that the masking fluid over the figure had leaked only a little, and it lifted and blended into shadow areas with a brush and clear water.

The fishing rod was carefully cut from the top layer of paper with the tip of a very sharp craft knife. I cut two lines, closer together at the tip and widening slightly closer to the figure, then peeled away the thin layer of paper to expose the white underneath. With a bit of color added, the rod looks fairly natural against the dark hillside.

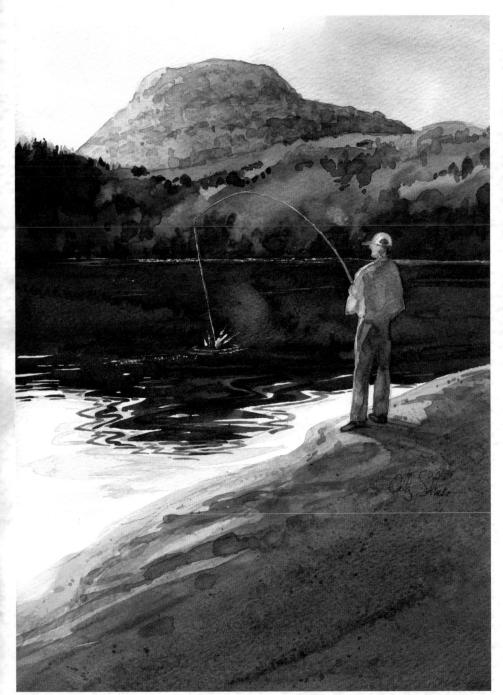

Joseph at Sunset Watercolor on Strathmore cold-pressed paper 12" × 9" (30cm × 23cm)

5 Add Finishing Touches to Water This is the finished painting—a bit more work on the

This is the finished painting—a bit more work on the closer edge of the water and some sparkles scratched out with a sharp knife suggest light on water.

I'm still thinking of cropping the foreground a bit, even though there's a good flow through the painting. As you can see, the eye travels from lower left to right, up the figure and along the rod, then up to the shadowed side of the mountain and back down the V of shadow on the far shore to the man himself.

Detail

Lost and found edges soften the figure and keep it from looking pasted on. As usual, I let the colors run into one another to keep this from being too harsh or cartoonish. A bit of sunset-colored watercolor pencil makes him look lightstruck as well.

Conclusion

I love it when a new world opens up... and, as you've discovered, that's just what happens when we take a sketchbook, journal or watercolor block outside and begin to explore the world around us with an artist's eye. All sorts of things we'd never have noticed while whizzing by in a car—or even on a bicycle—suddenly capture our attention with their everyday magic.

Taking photos is great for later reference, and, if you're a pro, it can take as much time, concentration and pure artistry as most of us muster for our paintings and drawings. For the rest of us, they're just snapshots, with the emphasis here being "snap." We take one quick shot and move on to the next photo op. We can miss a lot.

When we stop and take time to respond, with pencil or pen or brush in hand, we see more than we could have imagined in our normal surroundings. We've formed a relationship. As my friend, fellow writer and artist Hannah Hinchman says, we have "won a moment in the unfolding universe" that can nourish us for years.

I hope you've tried out the exercises found in these pages and put together your own field kit with your favorite art supplies. I hope you've experimented with a variety of techniques to capture the wonderful differences we find in nature, from the desert to the mountains, from prairies to ocean breakers. Some subjects are more challenging than others, but all will keep us on our toes. We have to think about how we might capture that red-winged blackbird or fleeting sunset, carefully considering just which pigments would give us the effect we want. When we nail it—or even come close to the neighborhood—it's a kick!

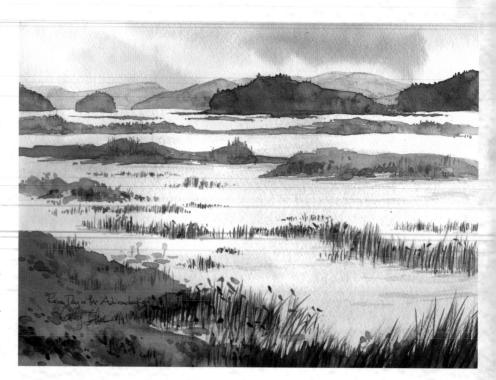

Rainy Day in the Adirondacks Watercolor on Strathmore cold-pressed paper $11" \times 14" (28 \text{cm} \times 36 \text{cm})$

Cut yourself some slack, and give yourself room to grow and develop. No one expects to play a Bach fugue the first time he or she sits down to an organ. It takes practice and attention.

Remember that the practice can be fun. It's play. New art supplies tempt us to splash around with color, try new things and stretch—relax and enjoy it! Practice isn't a chore; it's a lifelong delight. If you learn to love it as I do, you'll never be bored again.

You'll find yourself discovering more and more about nature, particularly if you form that relationship with nature that we talked

about in chapter six (see page 73), revisiting the same landscape through the seasons. If you choose a single tree as your focus, you'll learn to think of it as a friend.

When we take our painting kit on a trip with us, we bring the experience back to life. These memories last forever. Each time you look through your travel journal or at one of the plein air paintings you created in an unfamiliar locale, you'll find yourself recapturing the moments of your life. It will come back to you with startling clarity.

So enjoy the trip. The adventure has just begun.

Index

Α	Abstracted approach, 88		Fishing lures, 110		Reptiles, 99
	Antelope, 99		"Flowering" paint, 31		River, 57–58
			Flowers, 20, 89. See also Wildflowers		Rule of thirds, 32
В	Barn, 121		Forest habitat. 38–49. See also Trees		
	Bears, 45		Format, horizontal or vertical, 33	S	Seashore, 58–61
	Birds		Frog, 62		Shadows
	desert habitat, 98, 104				in forest, 41
	in field journal, 13–15	G	Grassland habitat, 68-81		in water, 67
	forest habitat, 46		Groundhogs, 78		Sheep, 90-91
	grassland habitat, 74, 75				Sketch journal, 8–21
	mountain habitat, 92	Н	Hiking, 117		Spatter, 95
	water habitat, 55, 58, 63		Humans in landscape, 110–121		Sponge, 43
	Bison, 78-81				Squirrel, 97
	Boats, 114-115	- 1	Inks, 28		Streams, 57–58
	Brushes				Sunlight, harsh, 107
	basic, 22	L	Lake, 51–54		Sunset, 112
	texture and, 93		Landscapes. See Desert habitat; Forest habitat;		Supplies, 22–29
	Brushstrokes, 65		Grassland habitat; Mountain habitat; Water habitat		Surfaces, 23
	Butterfly, 45		Lifting paint, 52, 61		
			Lighthouse, 121	T	Tent shapes, 113
C	Cabin, 121		Lizards, 99		Thumbnail sketch, 32, 65
	Cactus, 104				Tidal zone, 58–61
	Camera, 27	M	Mammals. See entries for specific mammals		Toned paper, 29
	Camping, 112–113		Marshes, 51–54		Travel journal, 16–19
	Canoe, 56, 114		Masking fluid, 60		Travel tools, 26
	Collage, 29		Materials, 19, 22–29		Trees
	Color, 34		Meadows. See Grassland habitat		bark, 42
	desert, 96		Mixed media, 28–29		deciduous, 94
	in field journal, 11		Moth, 45		distant, 40-41, 53
	moody, 37		Mountain habitat, 82–95		hollow branches, 13
	Color swatches, 75				in forest, 38-49
	Color wheel, 34–35	0	Ocean habitat, 58–61		in grasslands, 69
	Colored pencil, 28, 50		Opossum, 19		in mountains, 86–87
	Composition, 32–33				palm trees, 106
	Curves, 32	P	Palette		shape of, 38, 47
			colors in, 35		silhouettes, 86
D	Deer, 45		folding, 24		Turtle, 62
	Demonstrations		Paper		
	desert habitat, 97, 107-109		desert-toned, 100-101	V	Value, 36–37
	forest habitat, 47-49		toned, 29		Value sketch, 65
	grassland habitat, 79–81		watercolor, 23		
	humans in landscape, 115-116, 120-121, 122-125		Pencils, 22		
	mountain habitat, 91, 93-95		Pens, dip, 28	W	Washes, 30–31, 50, 60
	water habitat, 52-54, 59-61, 65-67		Petroglyphs, 103		Water containers, 25
Sec. 4	Desert habitat, 96–109		Plants		Water habitat, 50–67
d	Details, sketching, 54		in forest, 44		Watercolor field kit, 9
			in water habitat, 62		Watercolor paper, 23
F	Fence posts, 76		See also Flowers; Trees		Watercolor pencils, 24, 58
	Field journal, 10-11, 20-21		Pond, 51–54		Watercolors, tube vs. cake, 23
	Fields. See Grassland habitat		Prairies. See Grassland habitat		Waterfall, 64–67
	Figures, 56, 111, 118–119. See also Humans in landscape				Wildflowers, 17, 70-71, 88-89
	Fish, 63	R	Rabbit, cottontail, 77		Windmills, 76
	Fishing 116 122 125		Poffections in water 55 67		Woodshuck 12

Take Your Watercolor Paintings to the Next Level with these - other North Light Books:

Watercolor A to Z

By: Grant Fuller

ISBN 13: 978-1-58180-902-2

ISBN 10: 1-58180-902-6

Paperback semi-concealed spiral with easel • 192p • #Z0340

With 156 demonstrations in an alphabethical reference format, Watercolor A to Z is the ultimate must-have watercolor book for artists of any level. Its subjects include landscapes, people, wildlife, nature, and more. Featuring a self-standing, wire-o binding that stands on any flat surface, this book brings instruction to the painting process like never before.

Fill Your Watercolor with Nature's Light

By: Roland Roycraft ISBN 13: 978-1-58180-904-6 ISBN 10: 1-58180-904-2 Paperback • 144p • #Z0341

Featuring masking, pouring, and spattering techniques in fun methods, Fill Your Watercolor with Nature's Light incorporates a simple three-step process to preserve light and create atmosphere and texture in your paintings. Roland Roycraft gives a wealth of friendly and accessible instructions to enable any artist to paint beautiful light-filled landscapes and flowers.

Exploring Watercolor

By: Elizabeth Groves ISBN 13: 987-1-58180-874-2 ISBN 10: 1-58180-874-7 Hardcover • 144p • #Z0232

Learn how to enhance your painting style and expand your creativity in one of the most popular mediums among artists. Exploring Watercolor by award winning Elizabeth Groves is user friendly with charts, color wheels, and other easy-to-use features. It also has over 40 exercises and mini-demos that can be completed multiple times to achieve endless results.

These books and other fine North Light titles are available at your local arts & craft retailer, bookstore or online supplier or visit our website at www.fwbookstore.com.